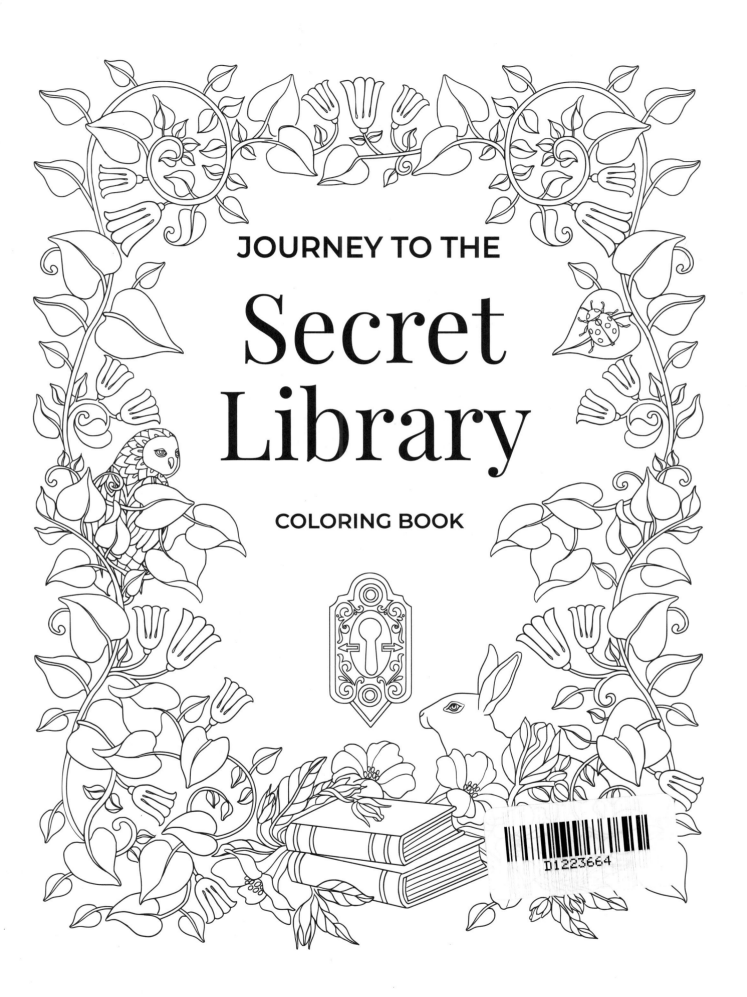

# JOURNEY TO THE

# Secret Library

## COLORING BOOK

Journey to the whimsical garden, enjoy a magnificent kingdom, filled with enchanting flowers and delightful creatures.

Journey to the mysterious island, find majestic animals and exotic sea creatures amid a tropical landscape.

ISBN: 978-1-7359330-2-3

# Layout:

- All coloring pages are 2 page spreads

- Each coloring page is printed on one side of the page

- To create a double page spread with images on only one side, we have placed double page spread blank pages between each of the double page spread coloring pages

- Contains 30 2-page spreads (equivalent to 60 single coloring pages)

- All images are unique, high resolution images

# Protect your masterpiece!

As you begin your *Journey to the Secret Library*, plan ahead to protect your creation.

Because the coloring pages are 2 page spreads, any colored page may rub color onto the facing page. This is unavoidable simply because the nature of all coloring mediums is "to color". The presence of the coloring medium (whether crayon, marker, or pencil) on a page may result in color transference onto the facing page. We recommend that you use a sheet of paper on top of any colored page (or between facing colored pages) to prevent unwanted colors from being rubbed onto your blank or colored pages.

Because some coloring utensils, such as markers, contain more liquid than wax, the liquid may seep through the page you are coloring, causing "bleed through". As added security when using more liquid coloring mediums, you may opt to place some type of thick paper or card stock (a file folder works extremely well) behind your pages as you color.

By taking these additional steps, your coloring pages will be more protected, and your journey will be peaceful and enjoyable.

*Enjoy your journey!*

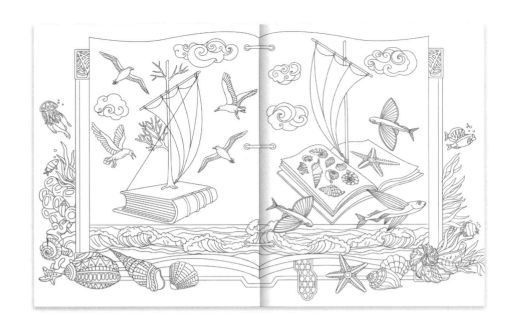

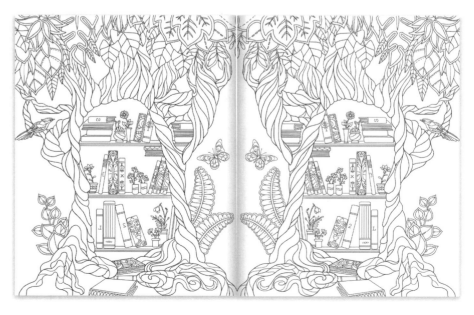

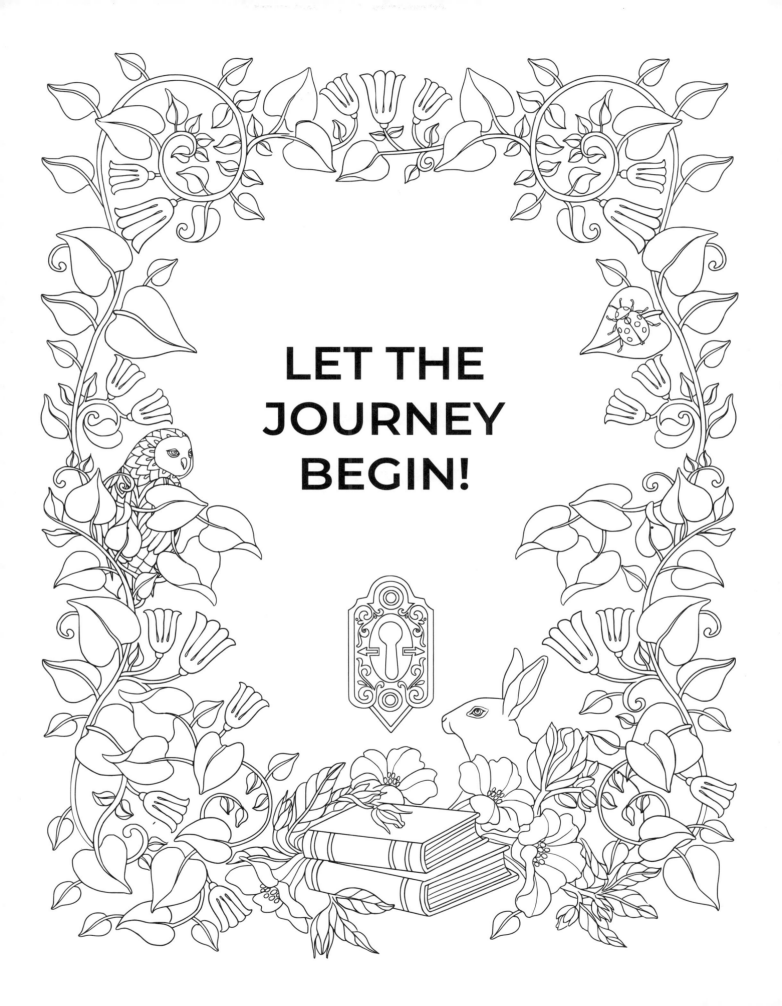

LET THE JOURNEY BEGIN!

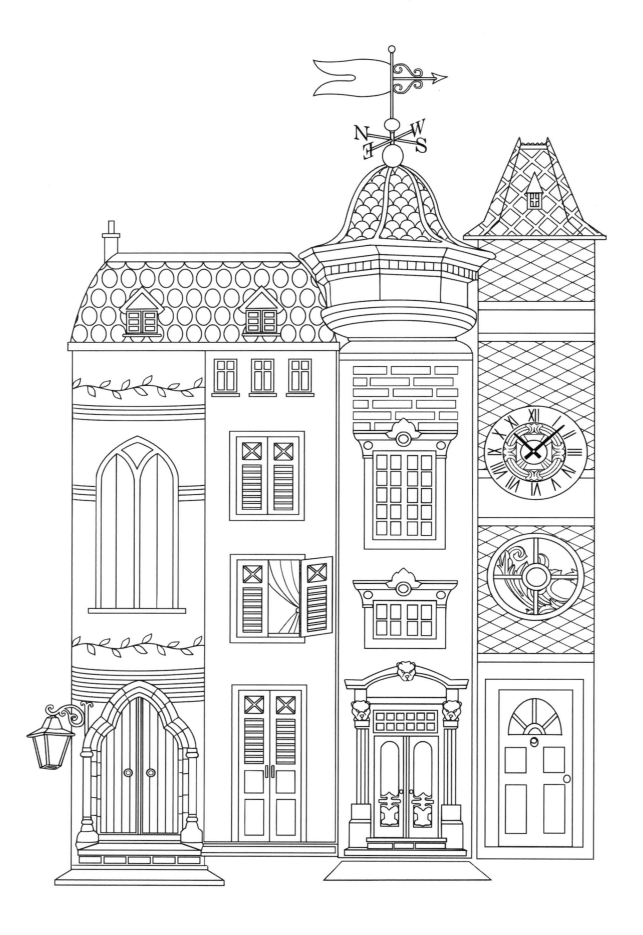

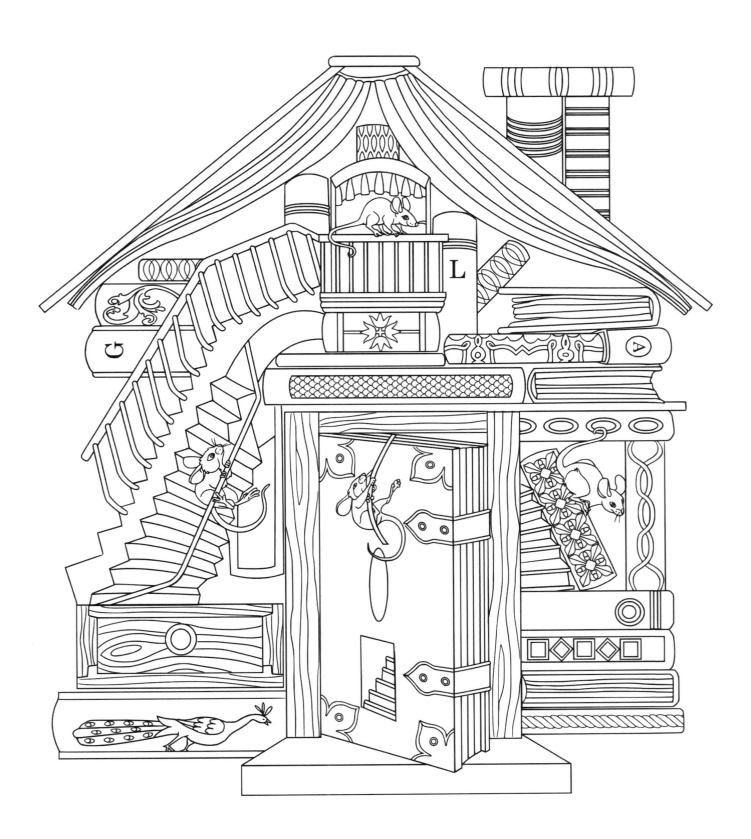

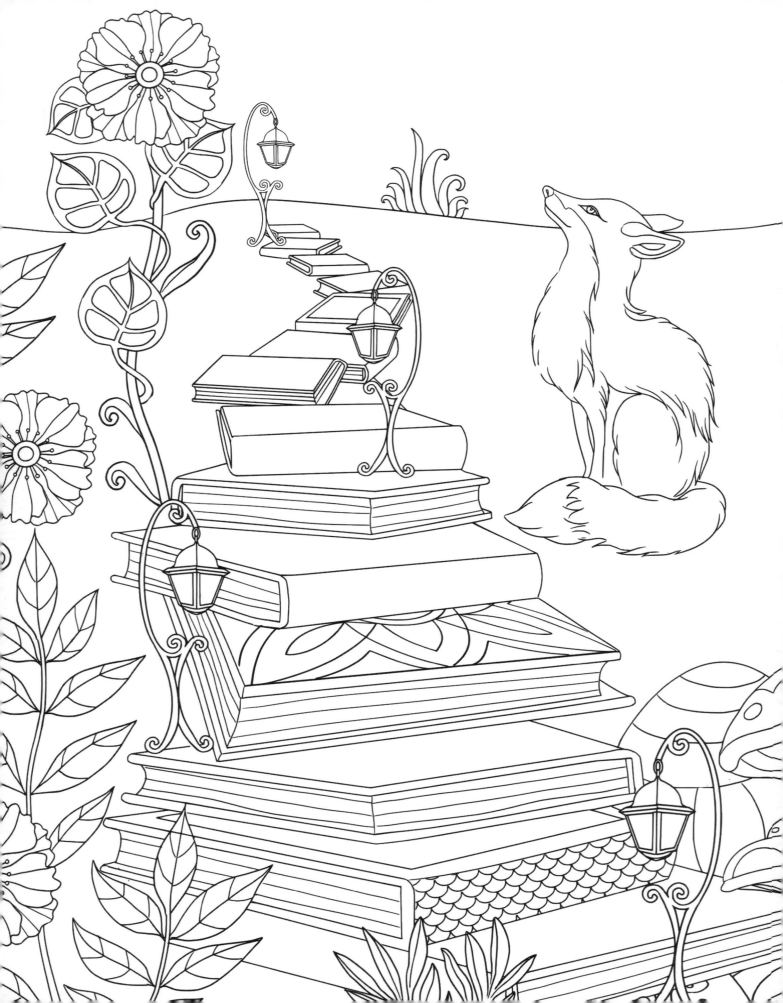

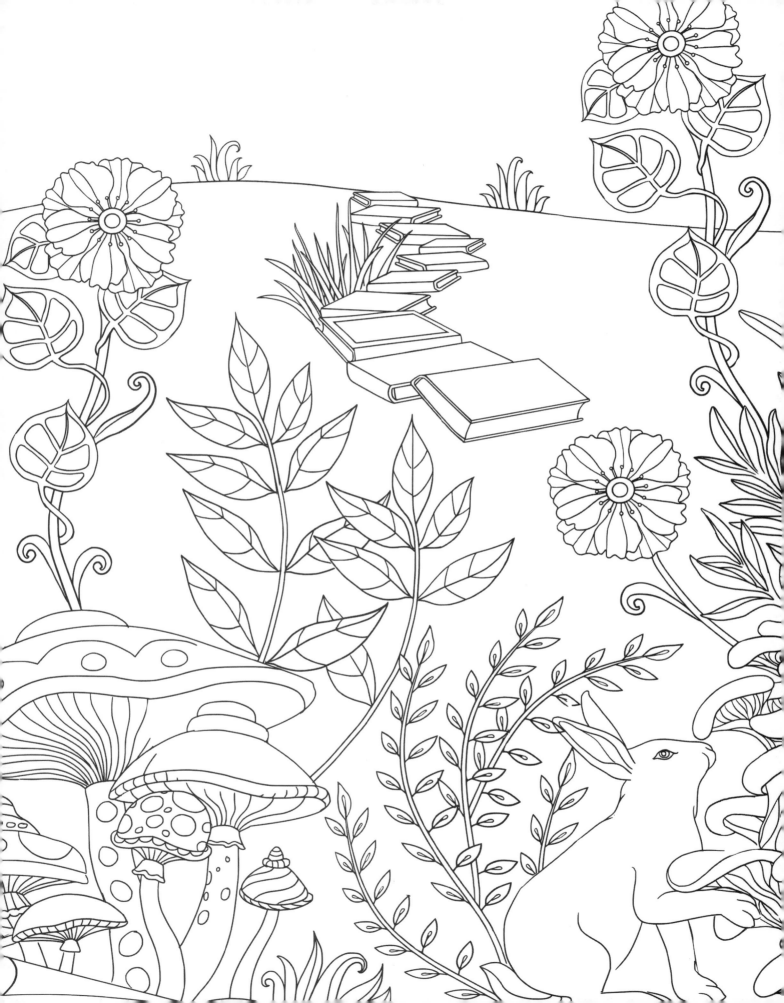

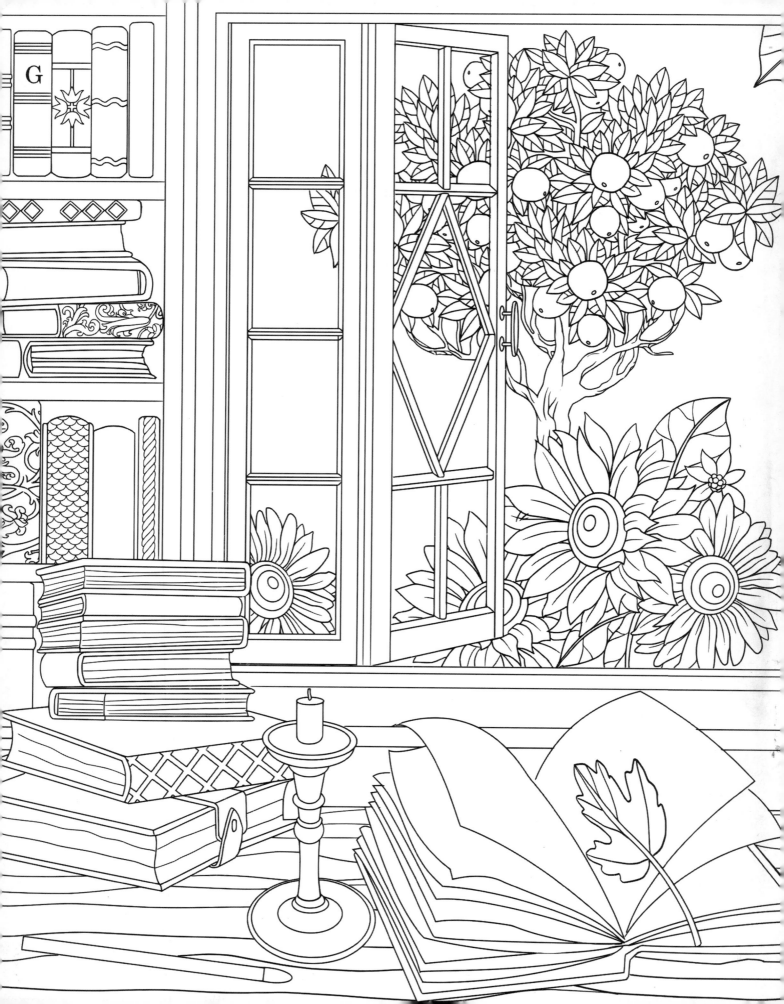

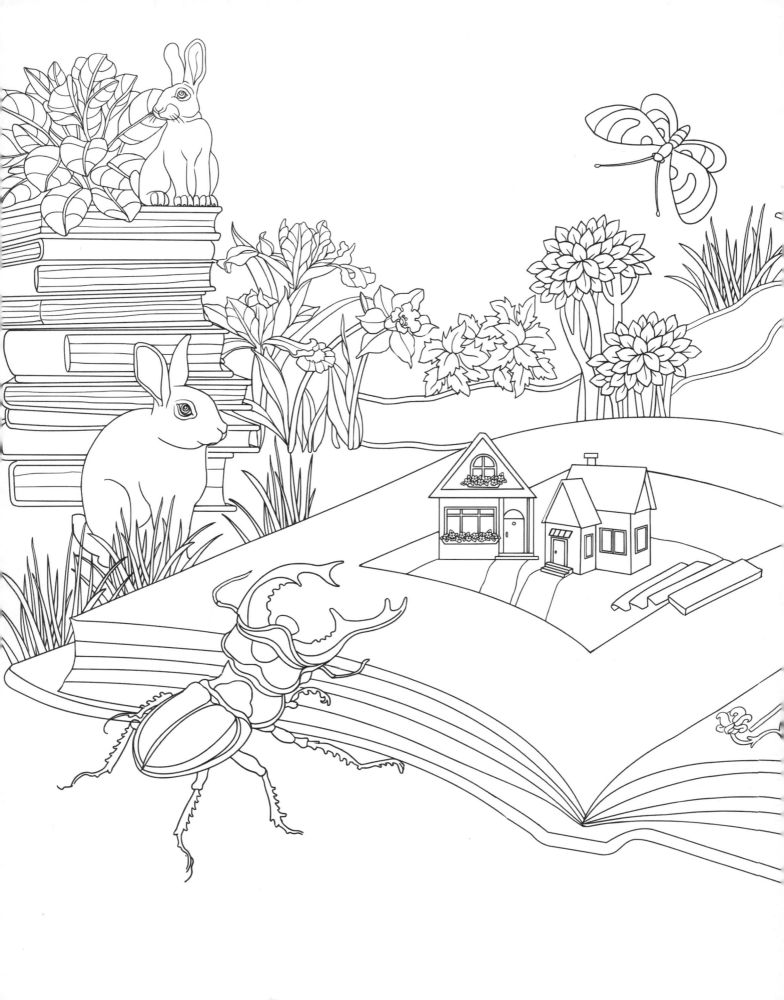

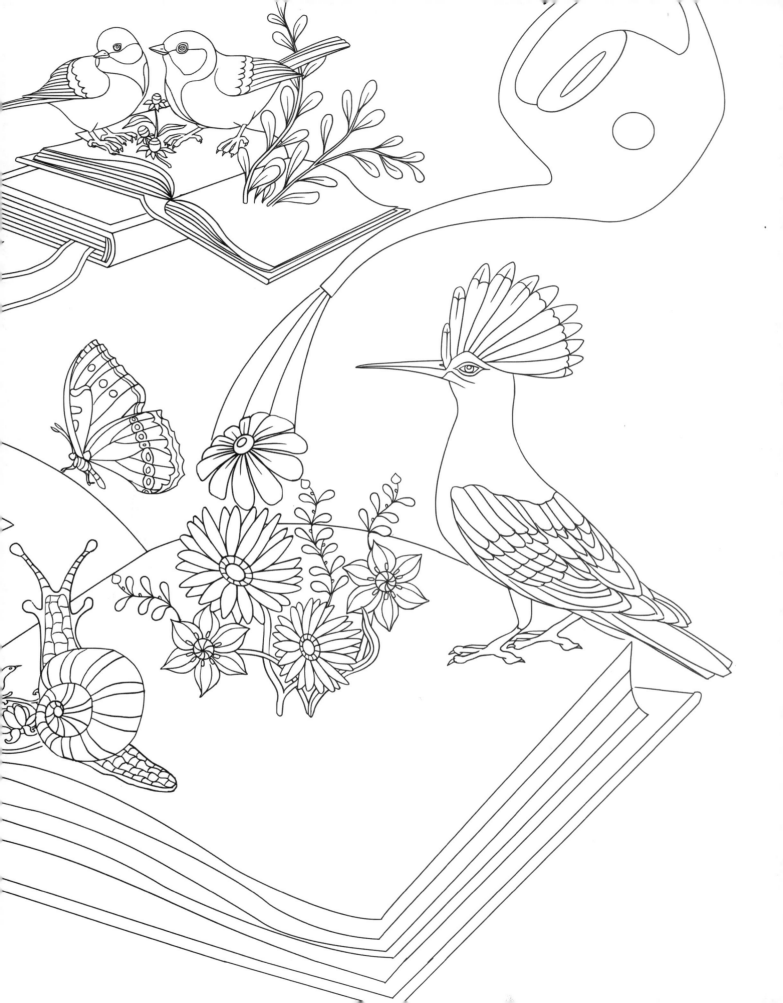

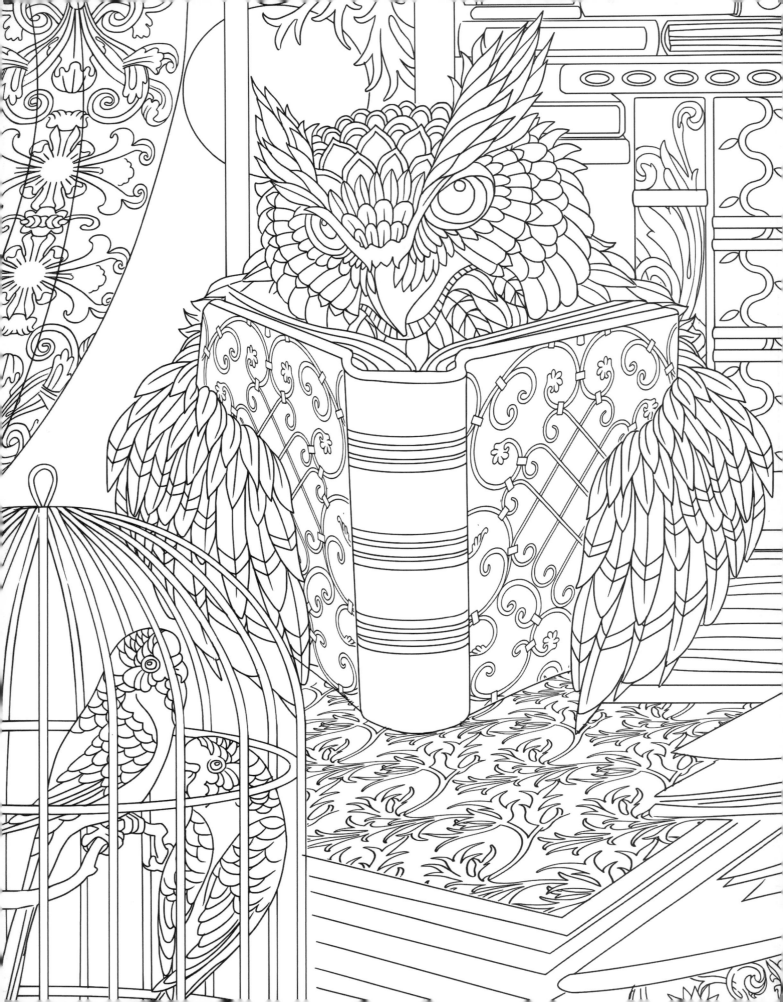

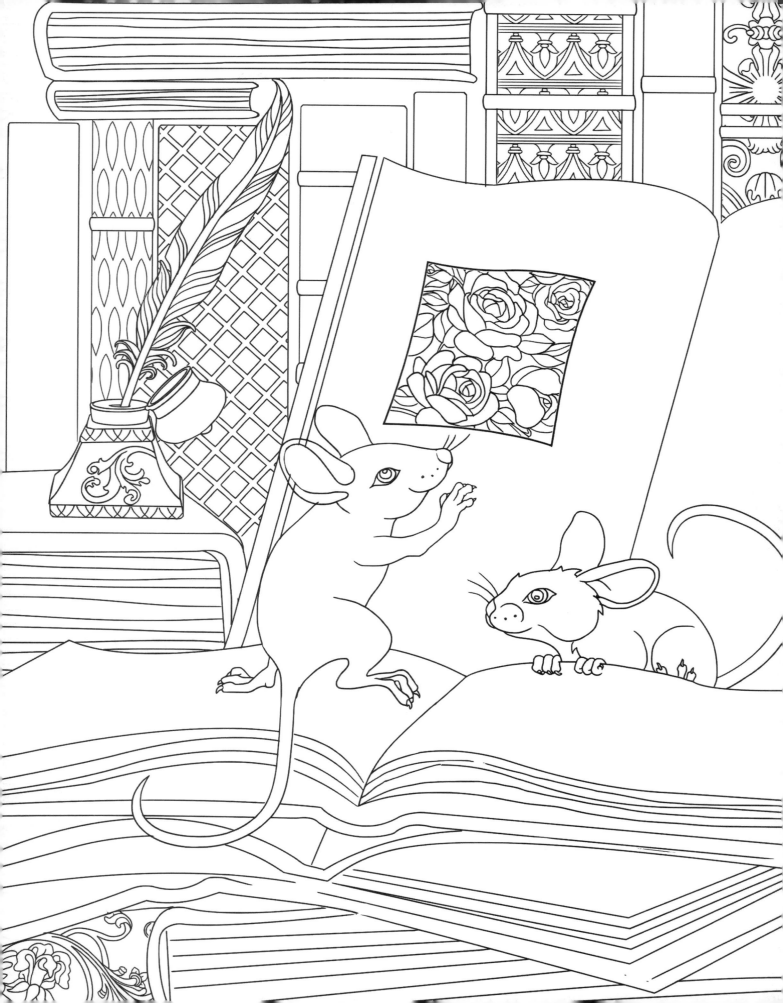

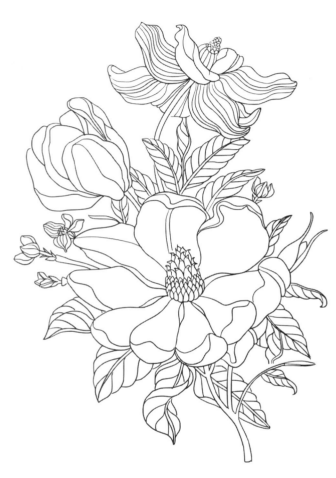

Magnolia

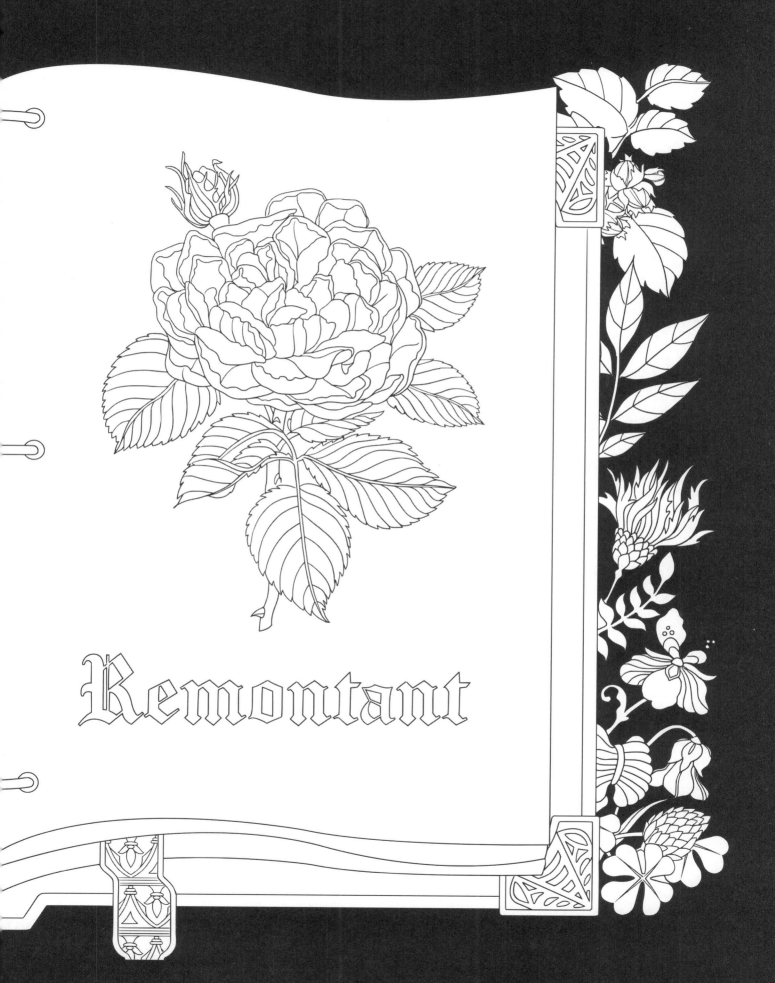

Remontant

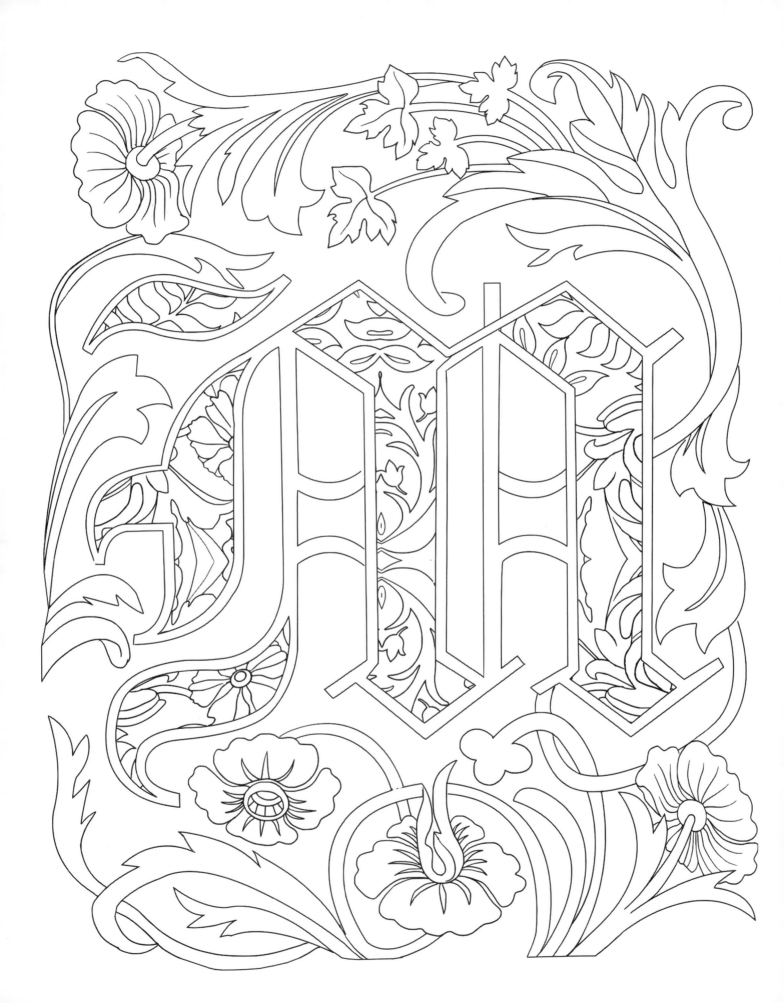

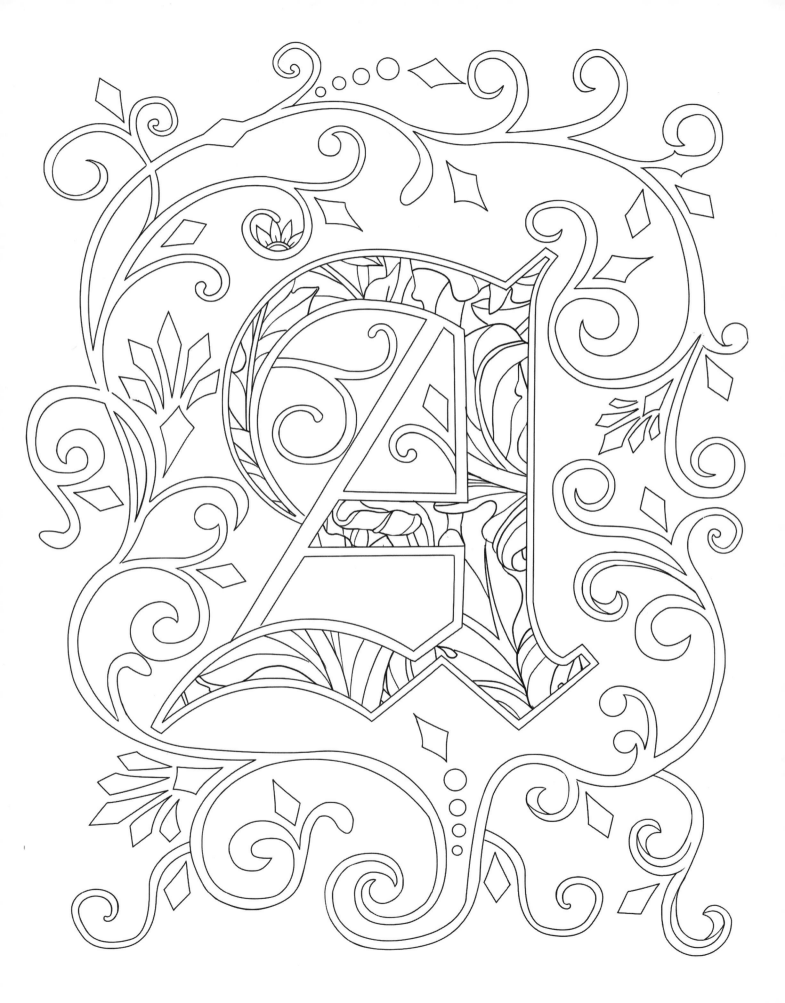

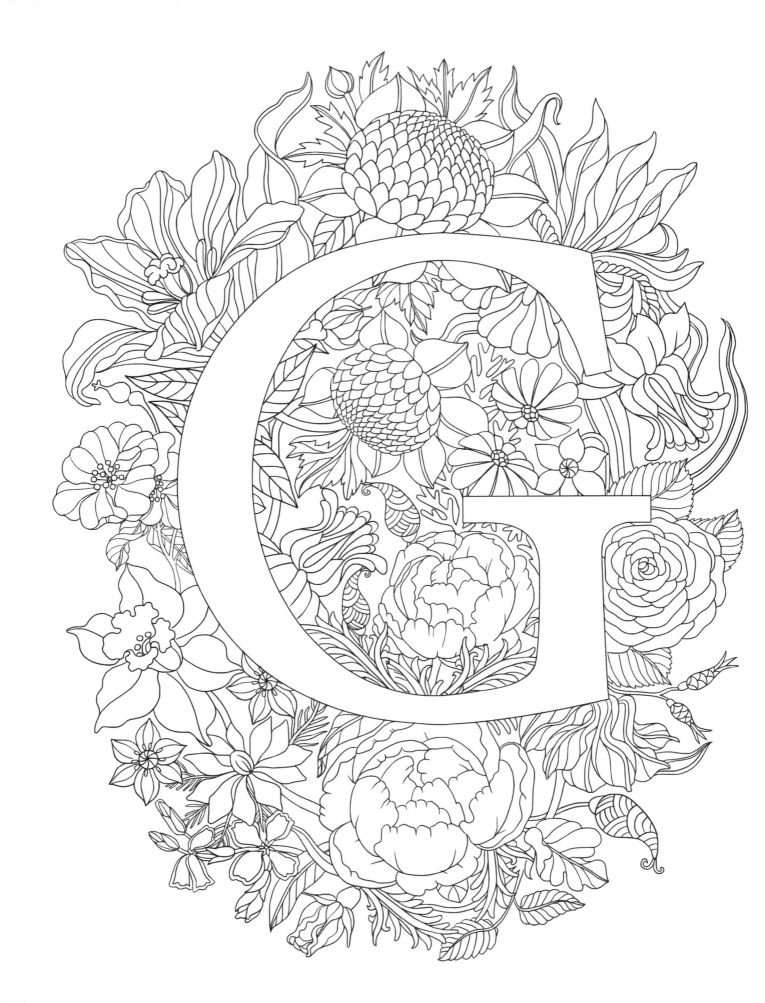

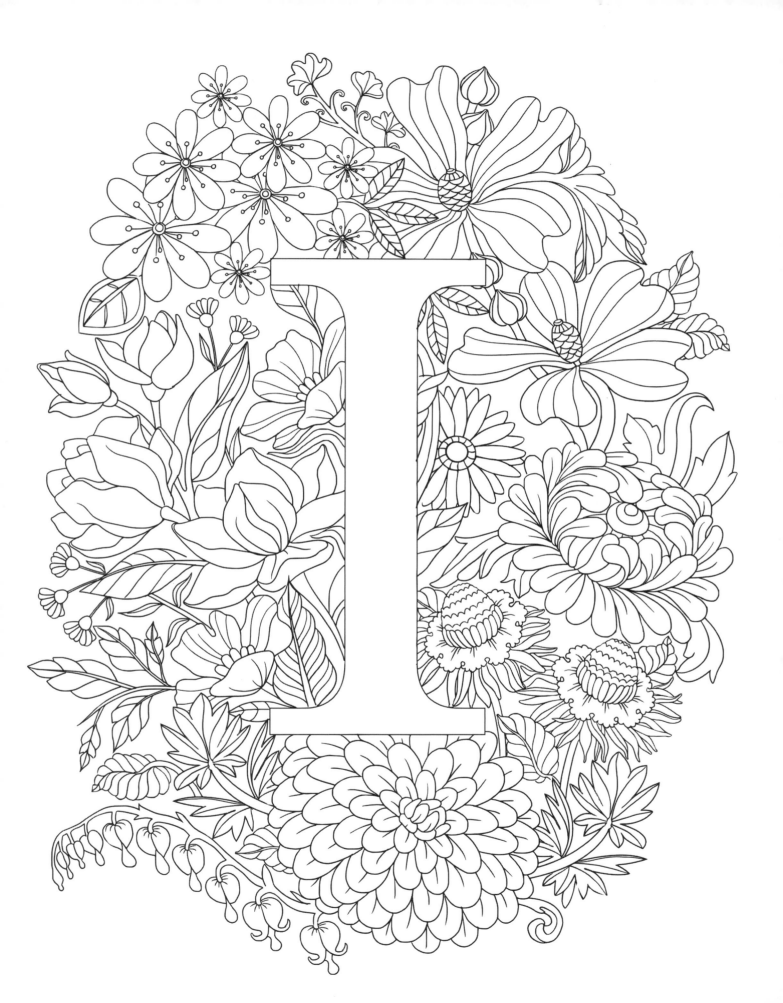

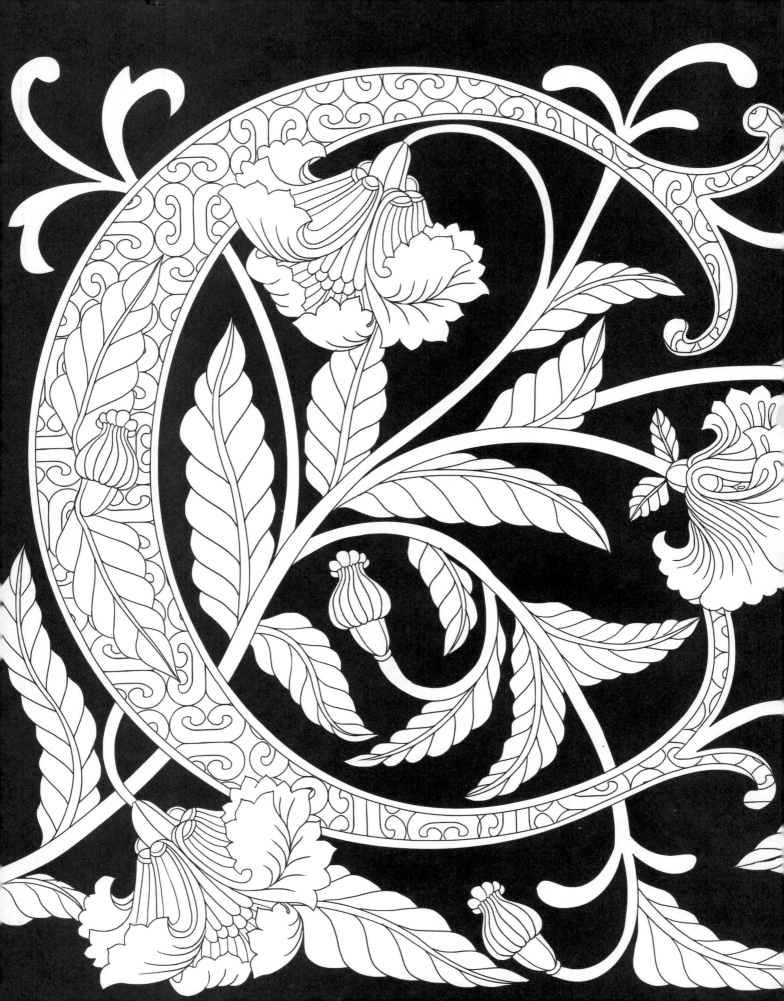

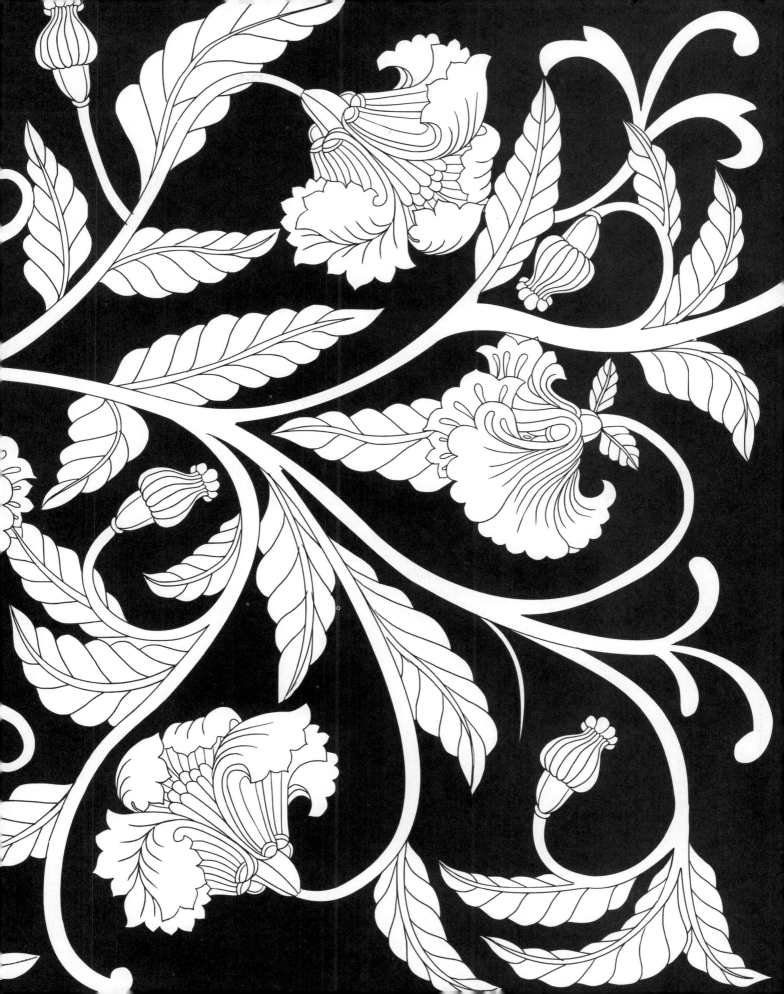

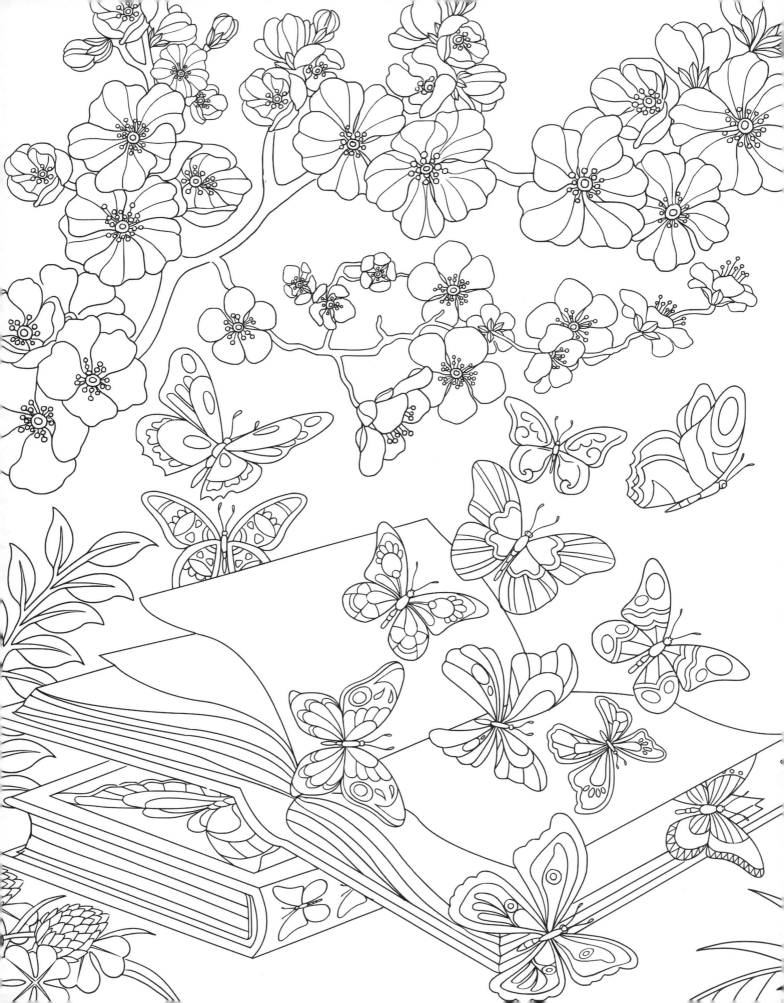

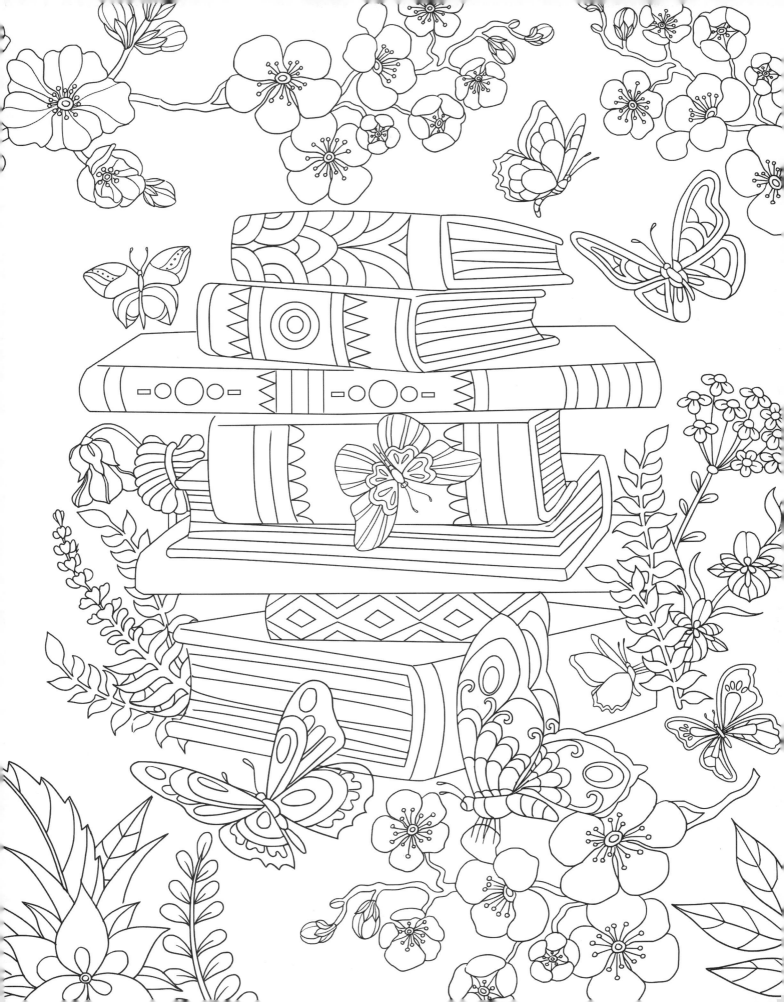

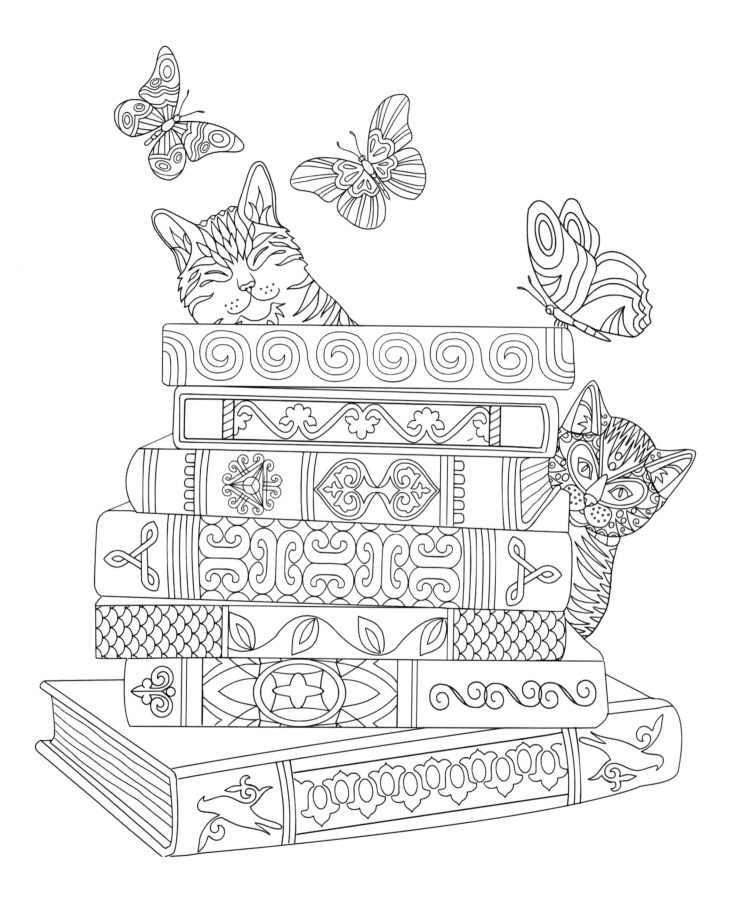

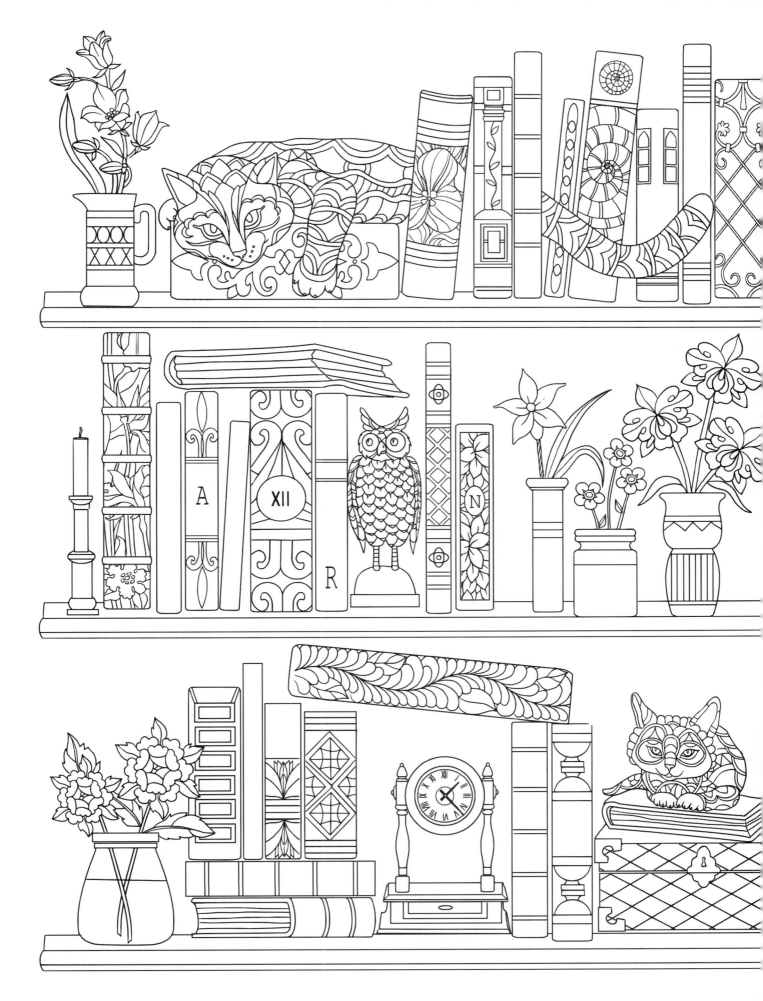

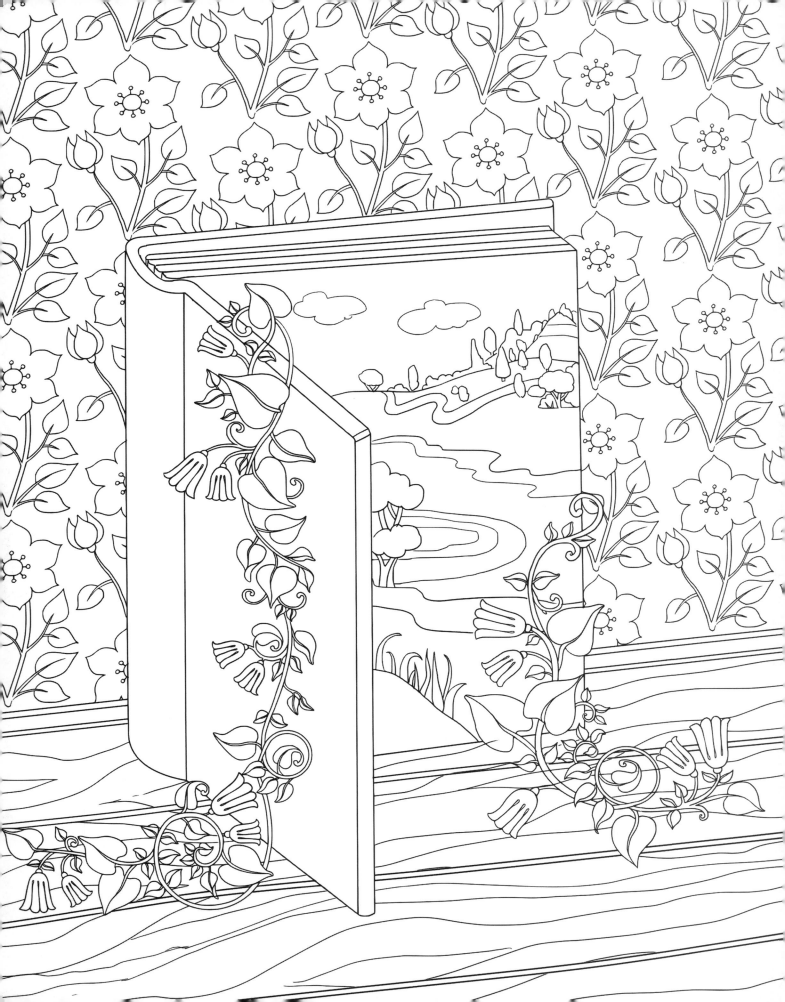

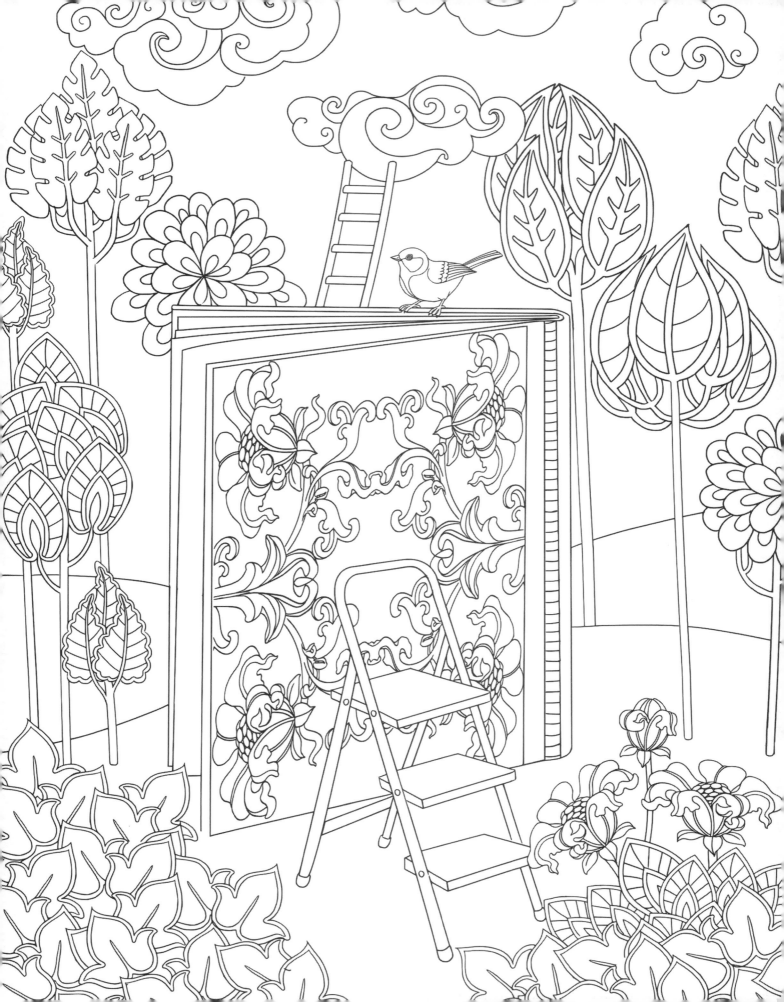

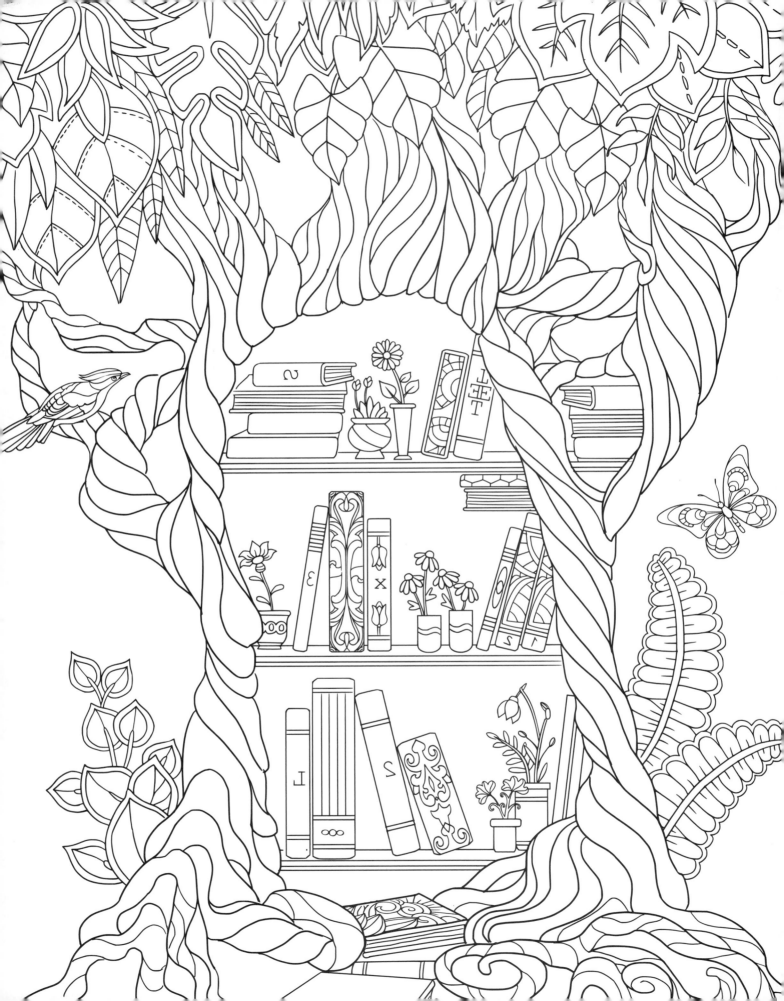

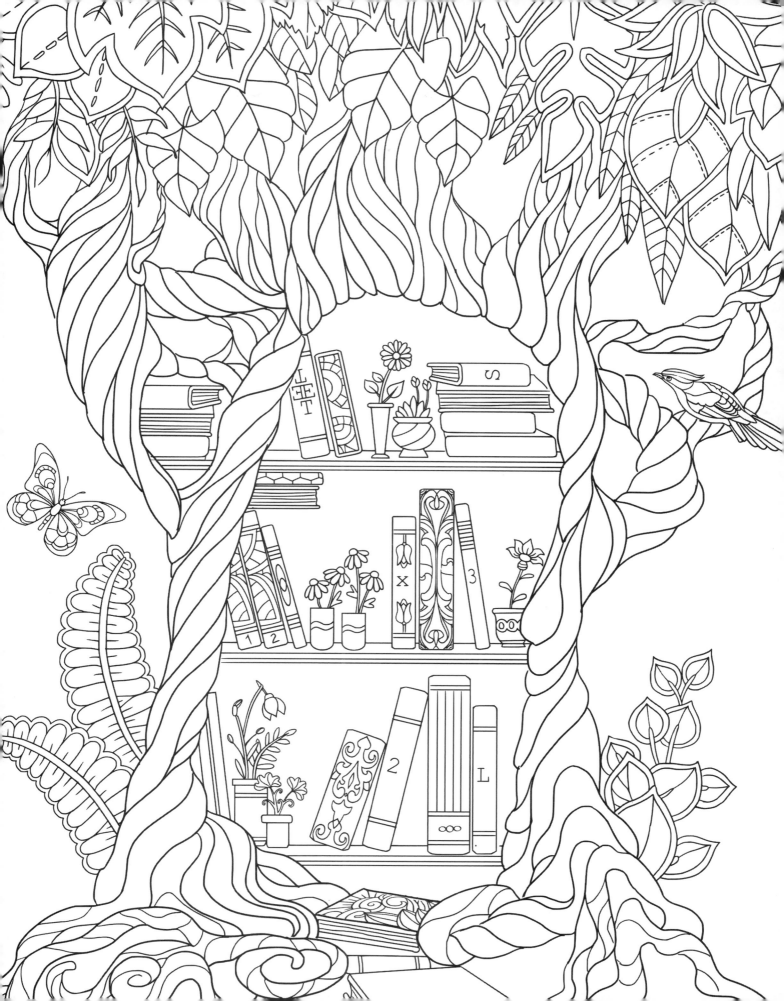

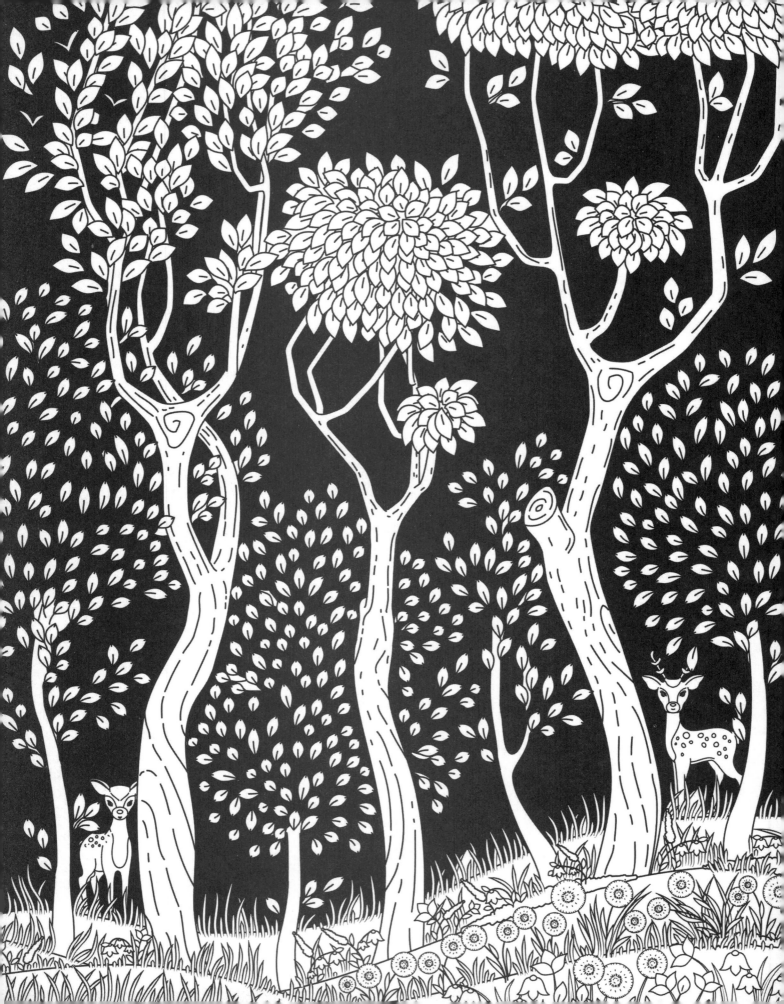

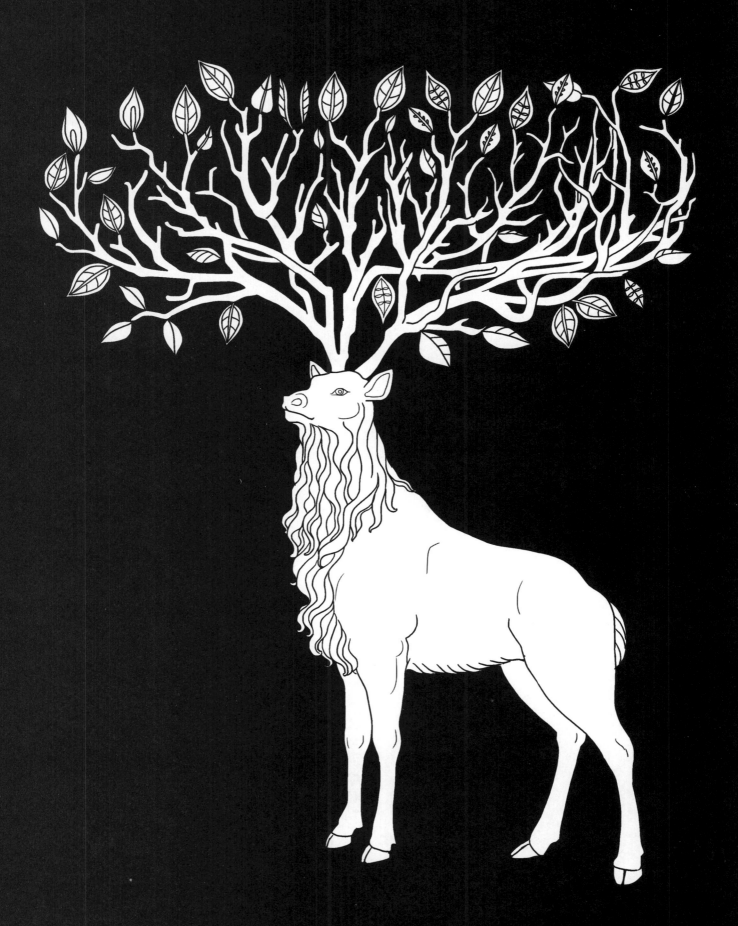

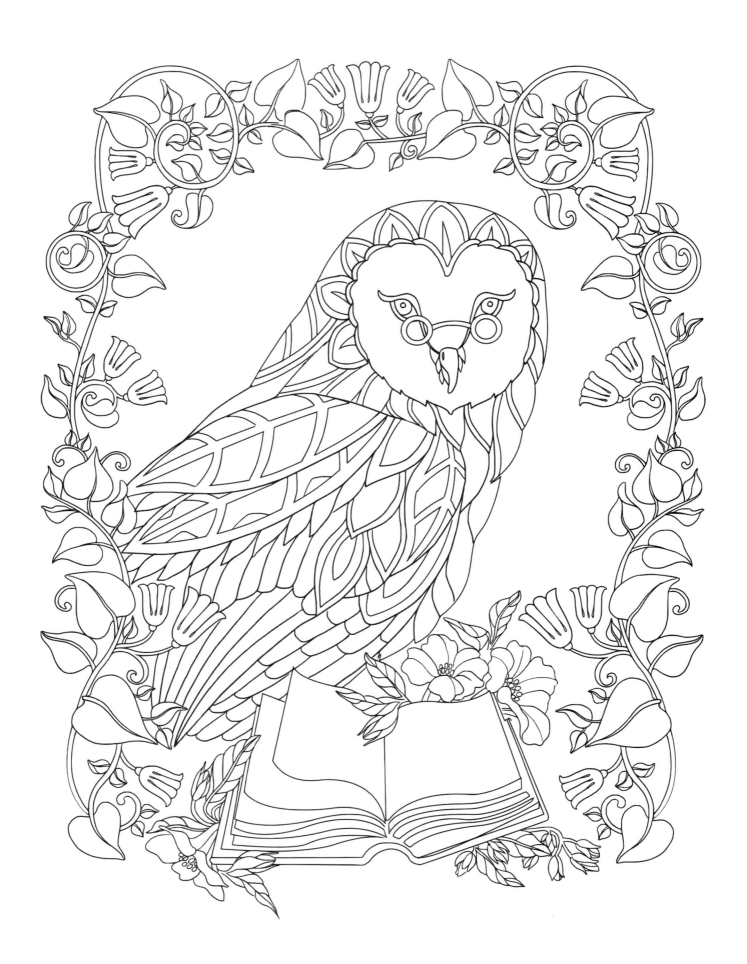

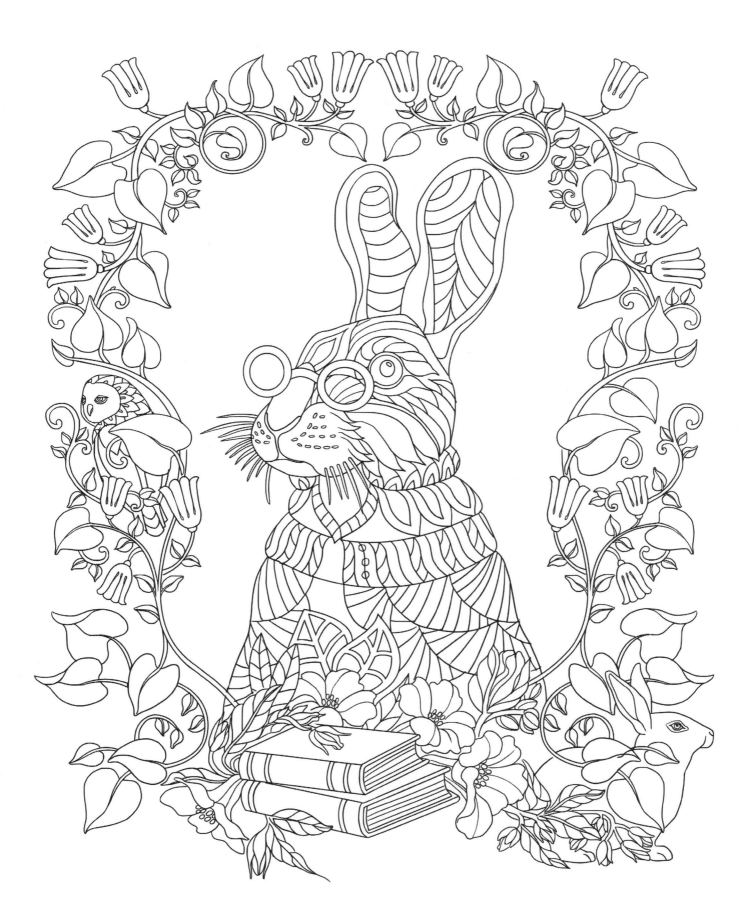

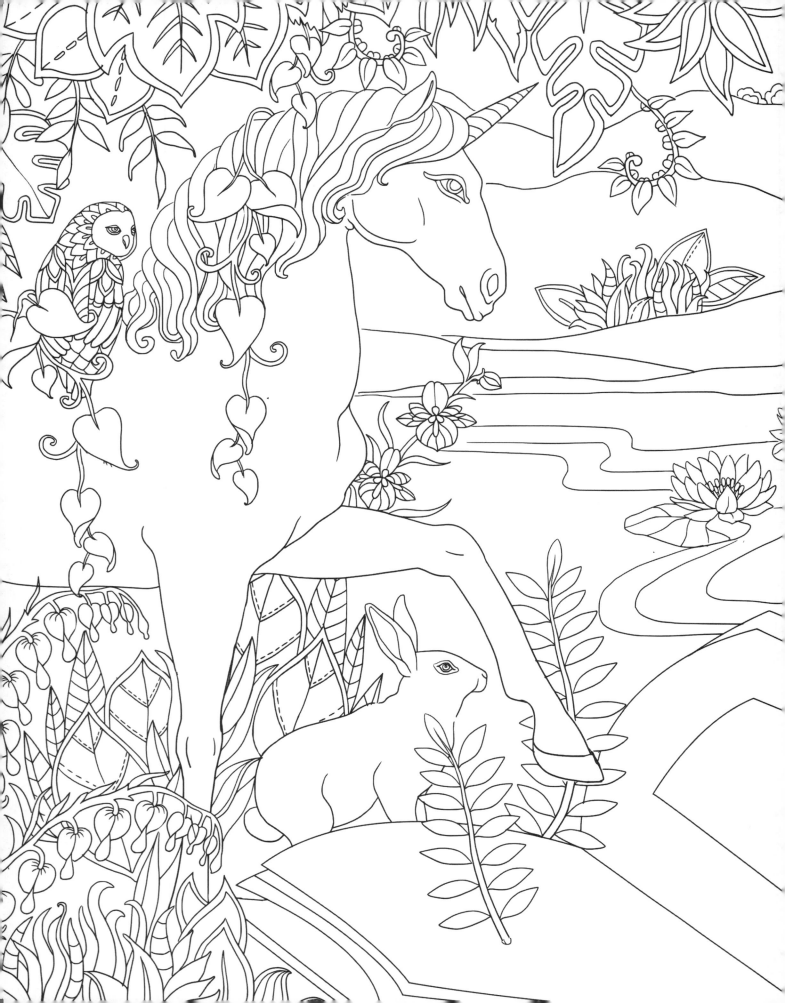

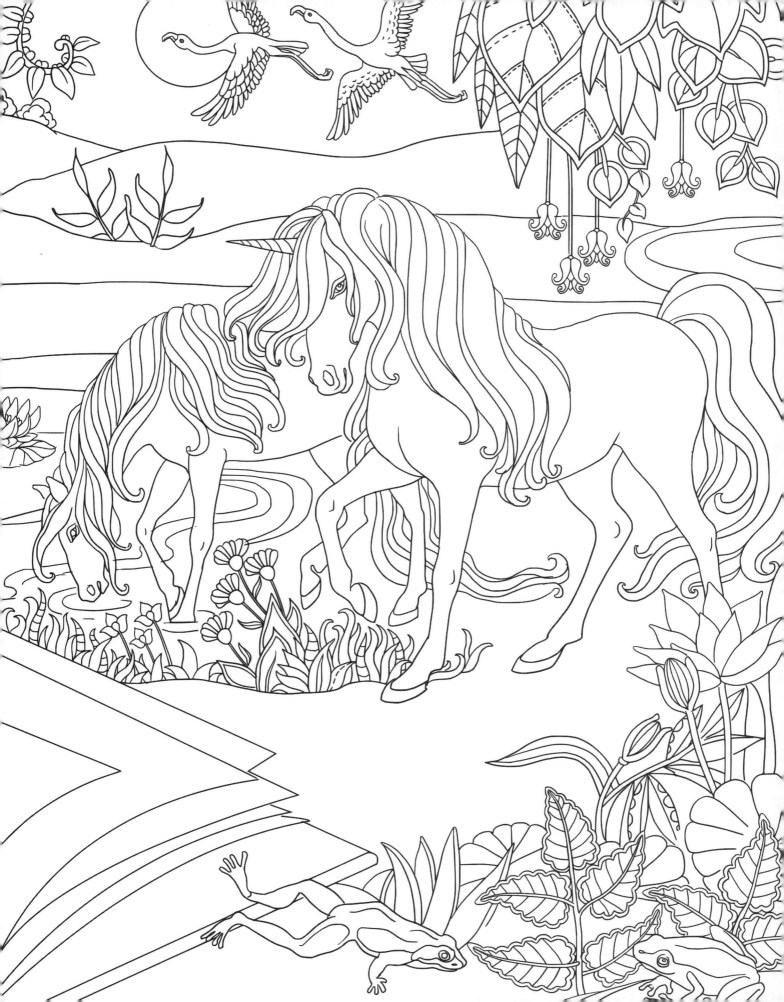

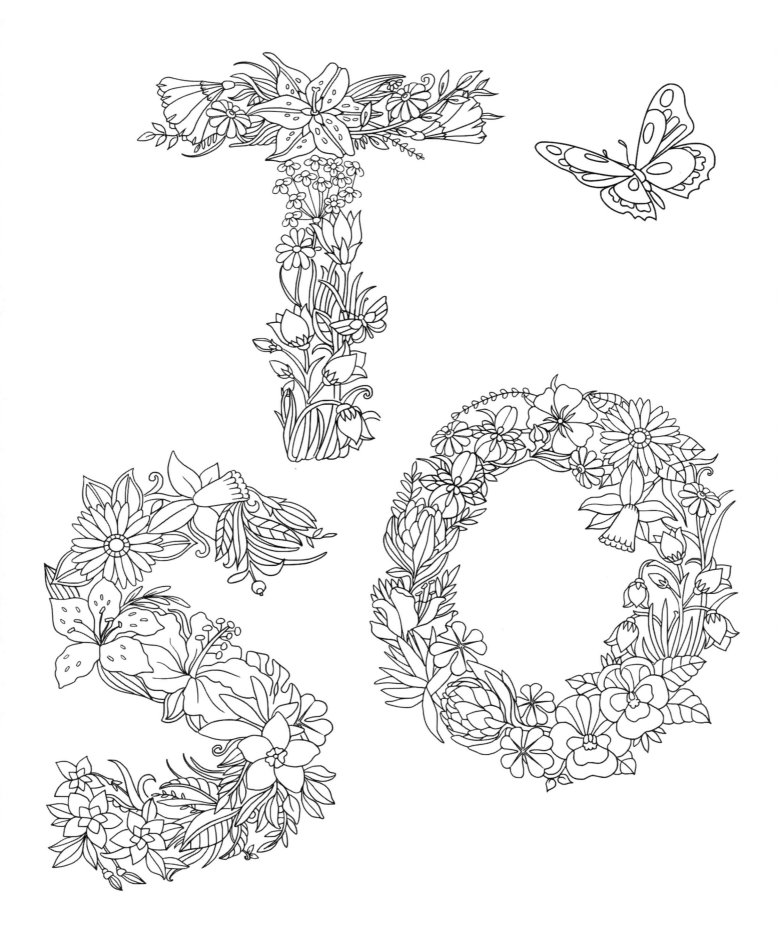

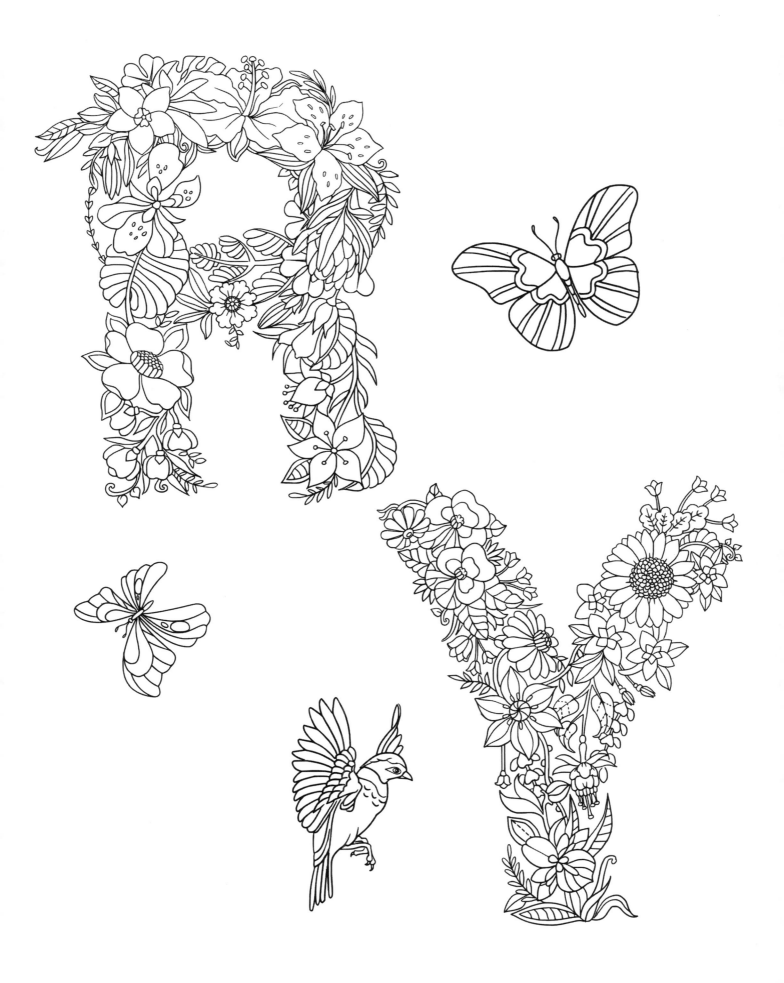

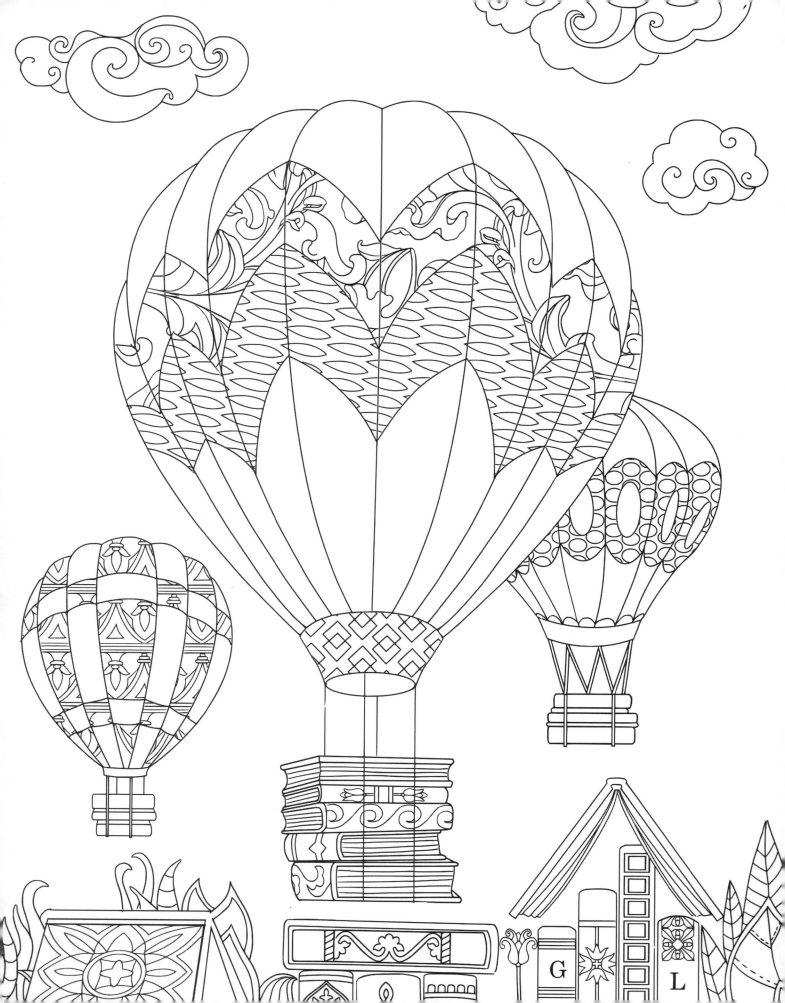

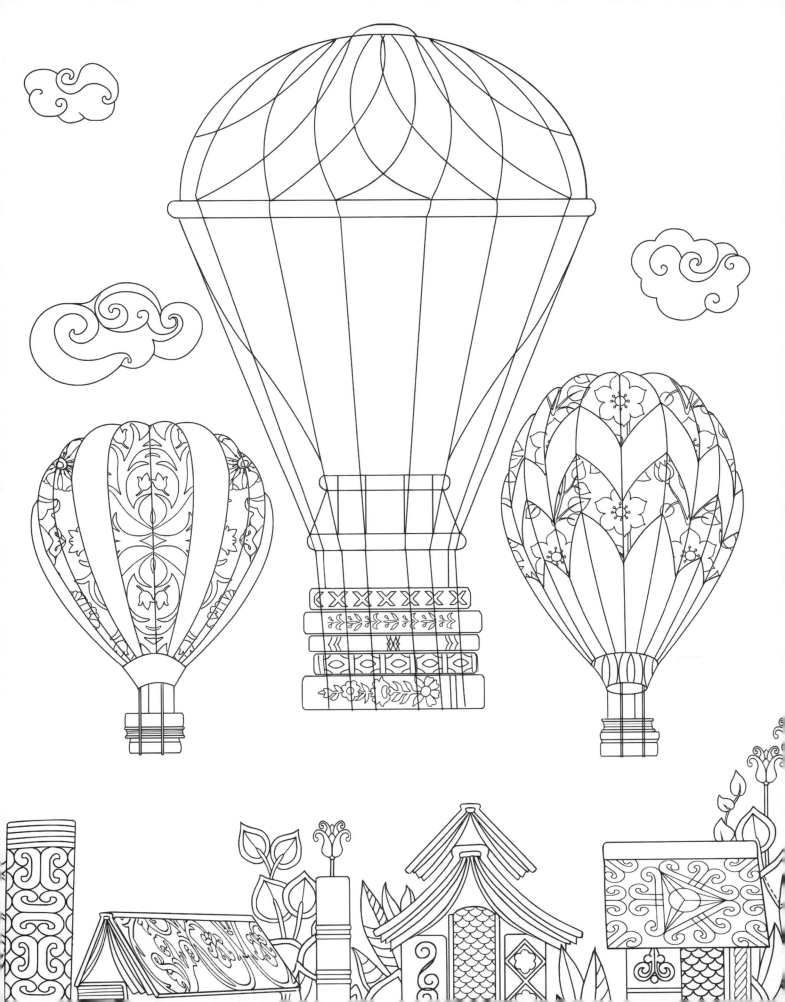

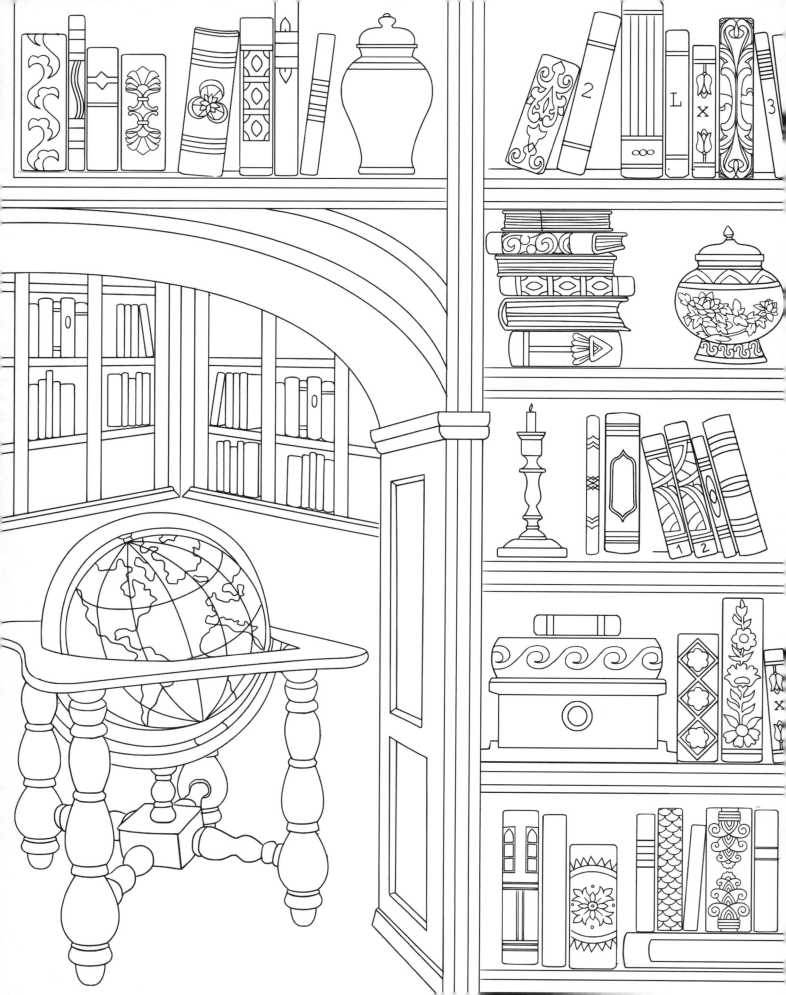

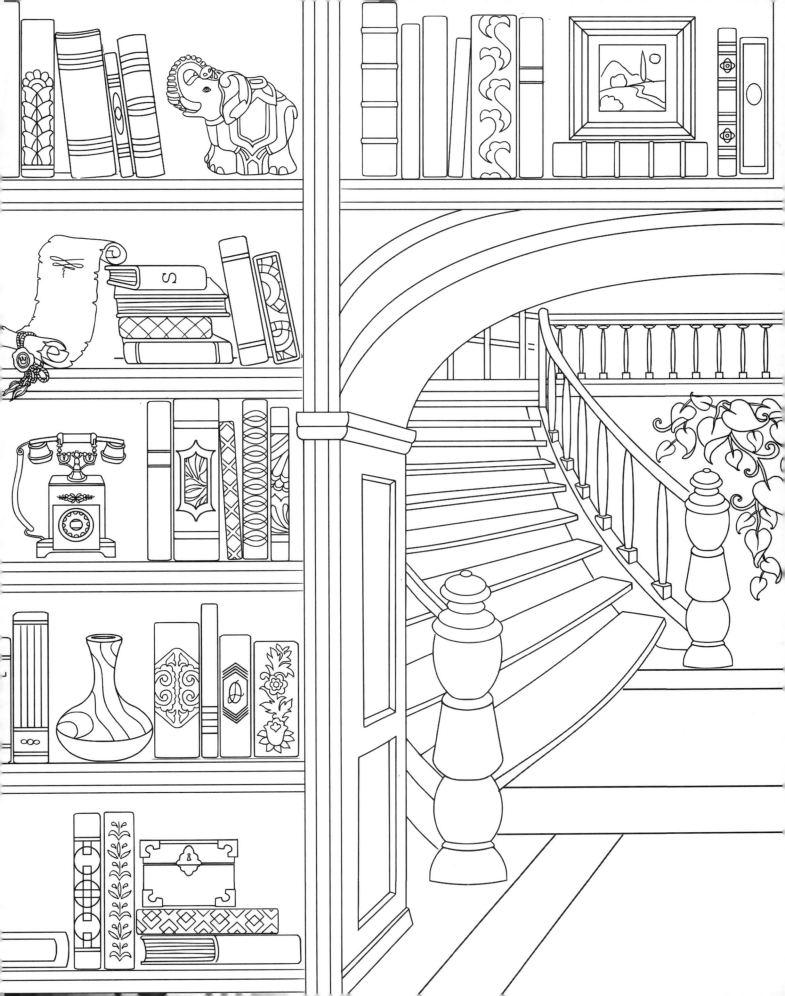

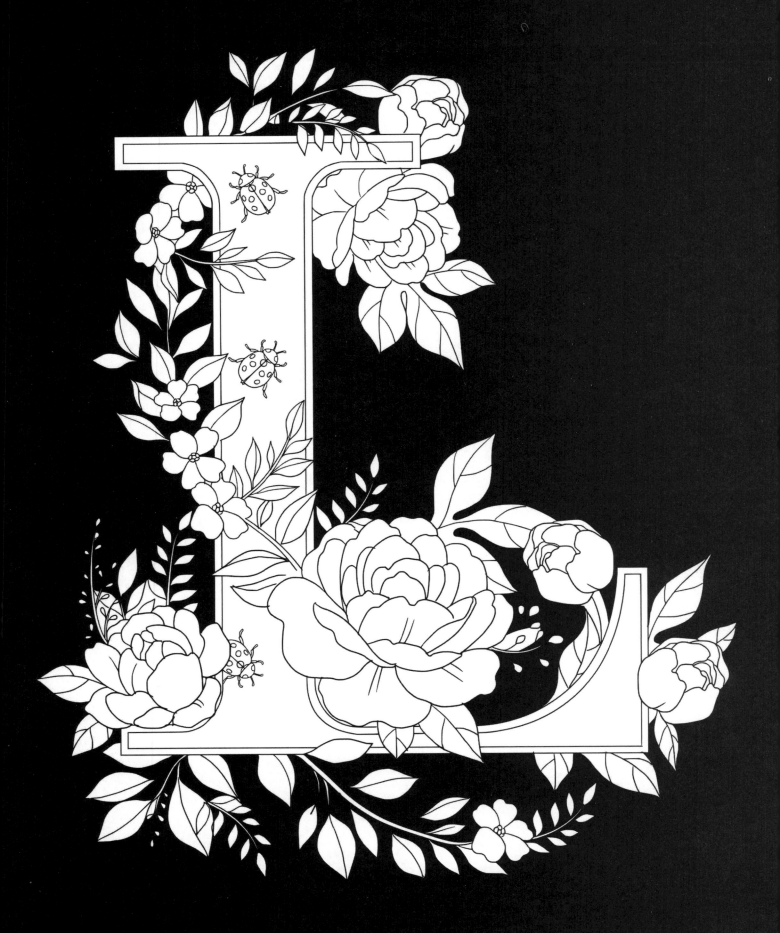

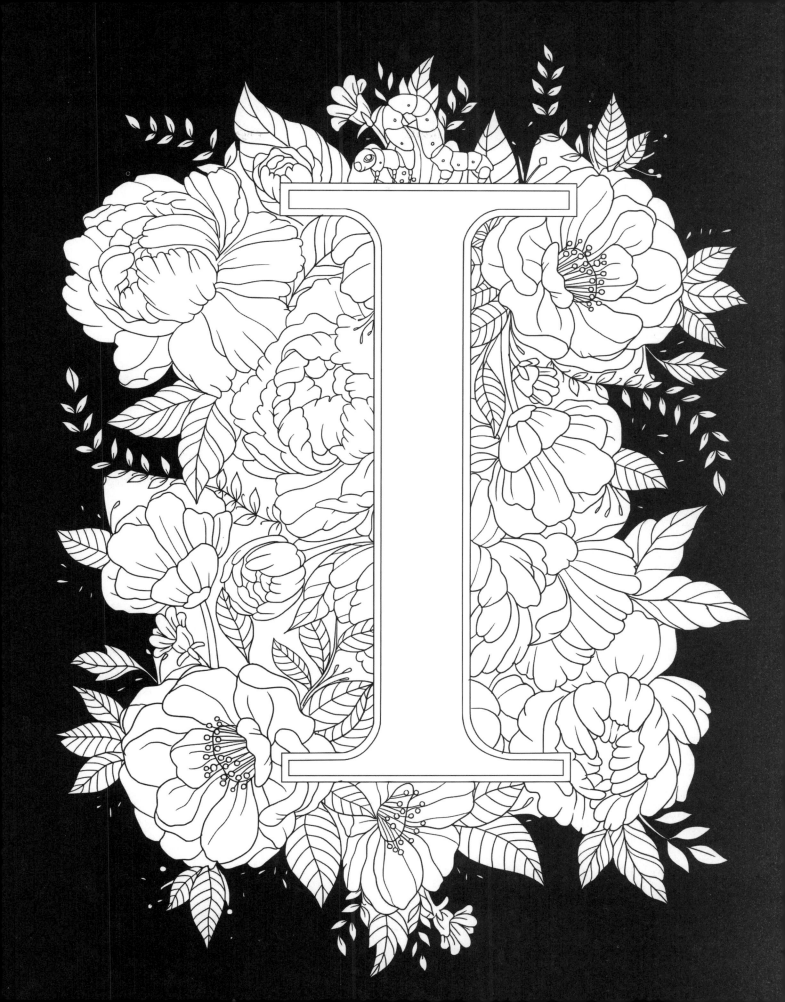

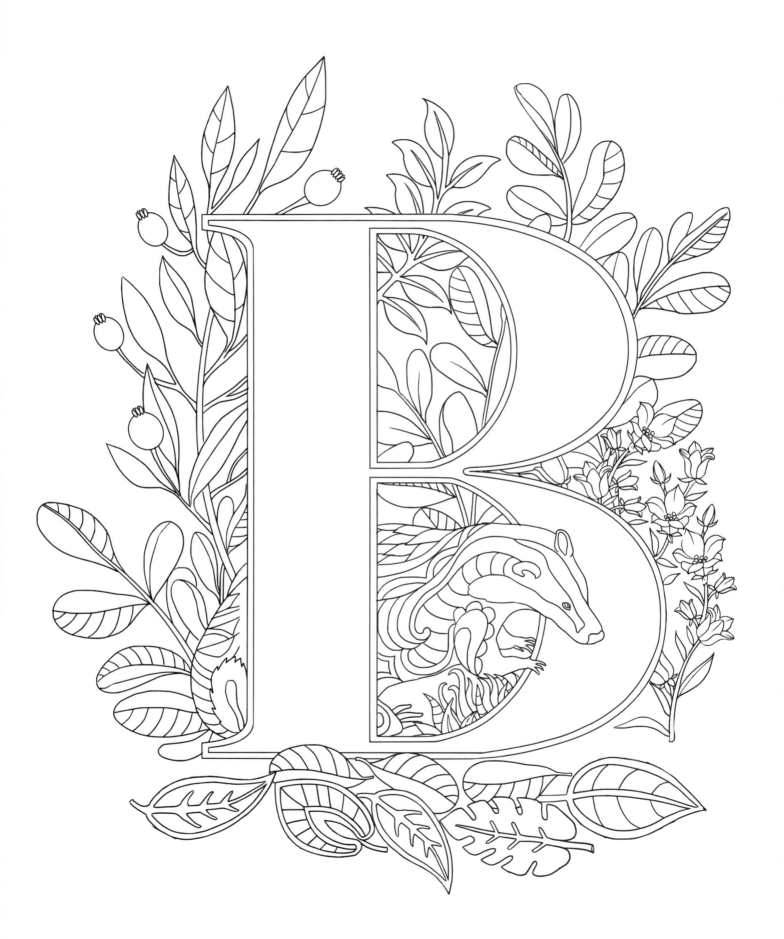

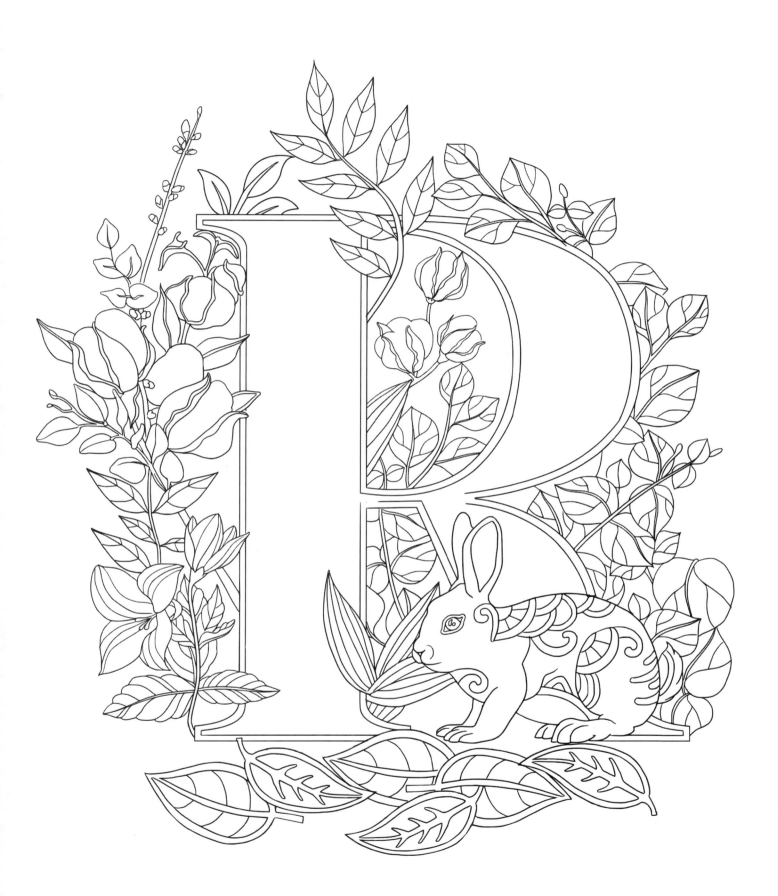

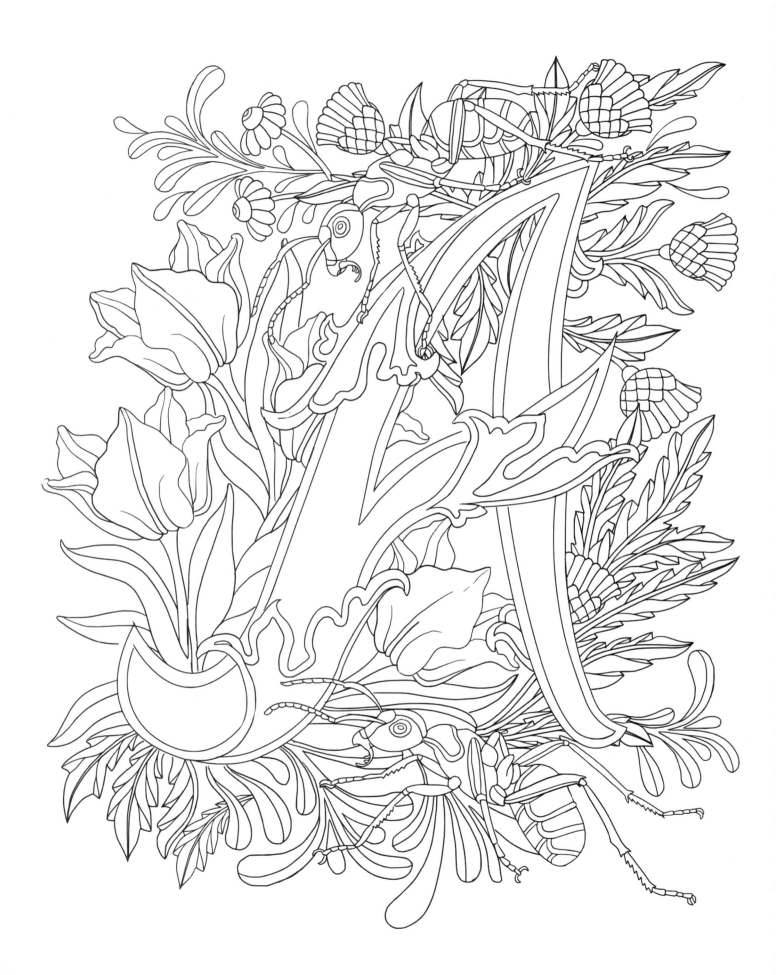

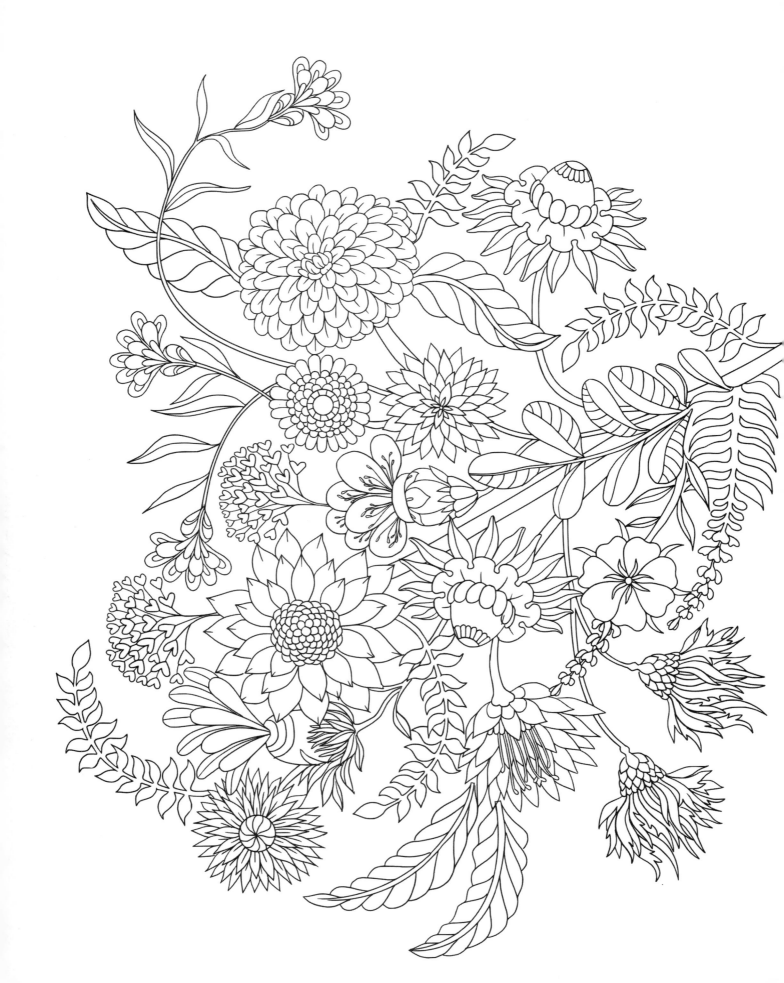

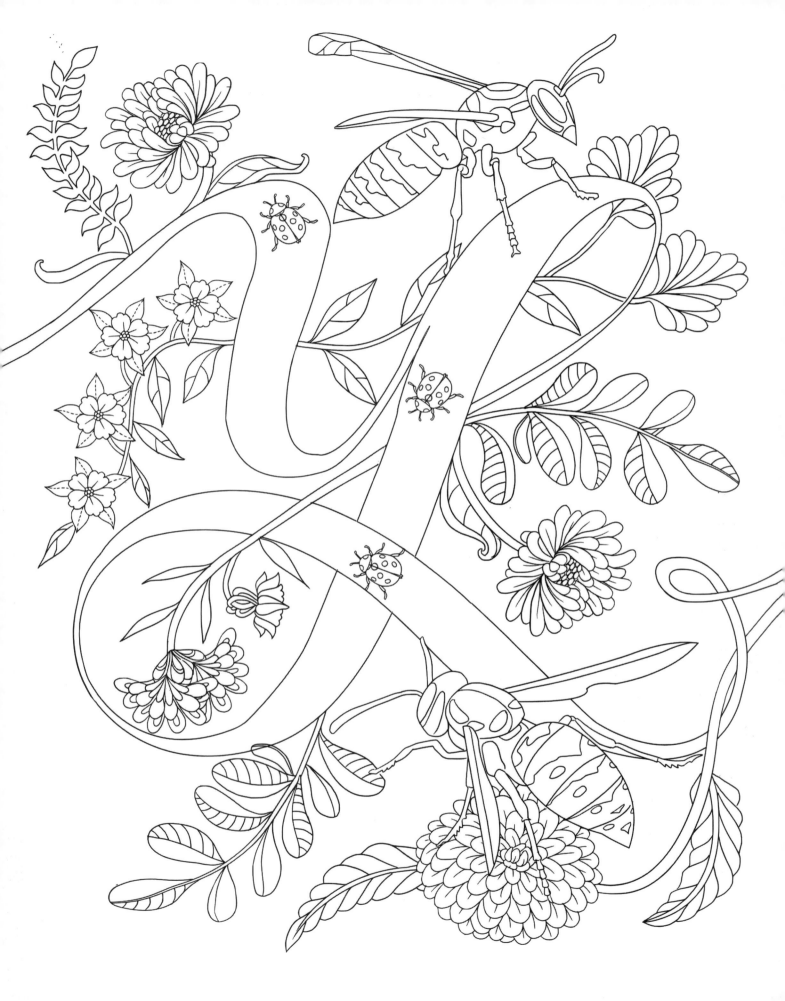

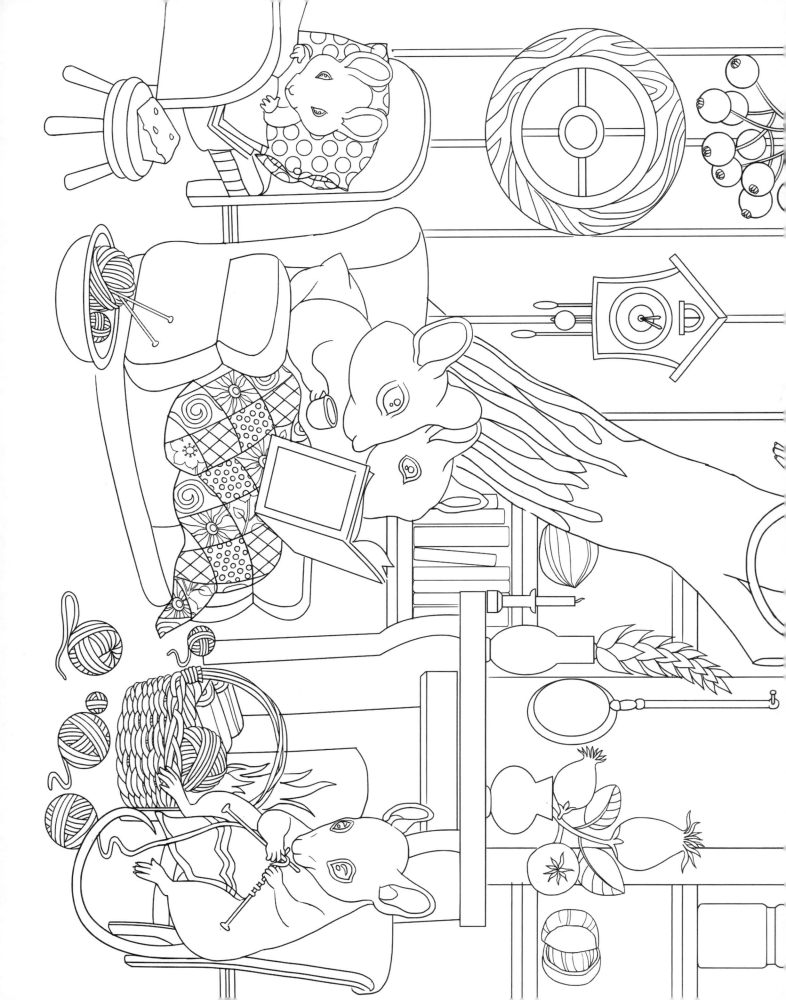

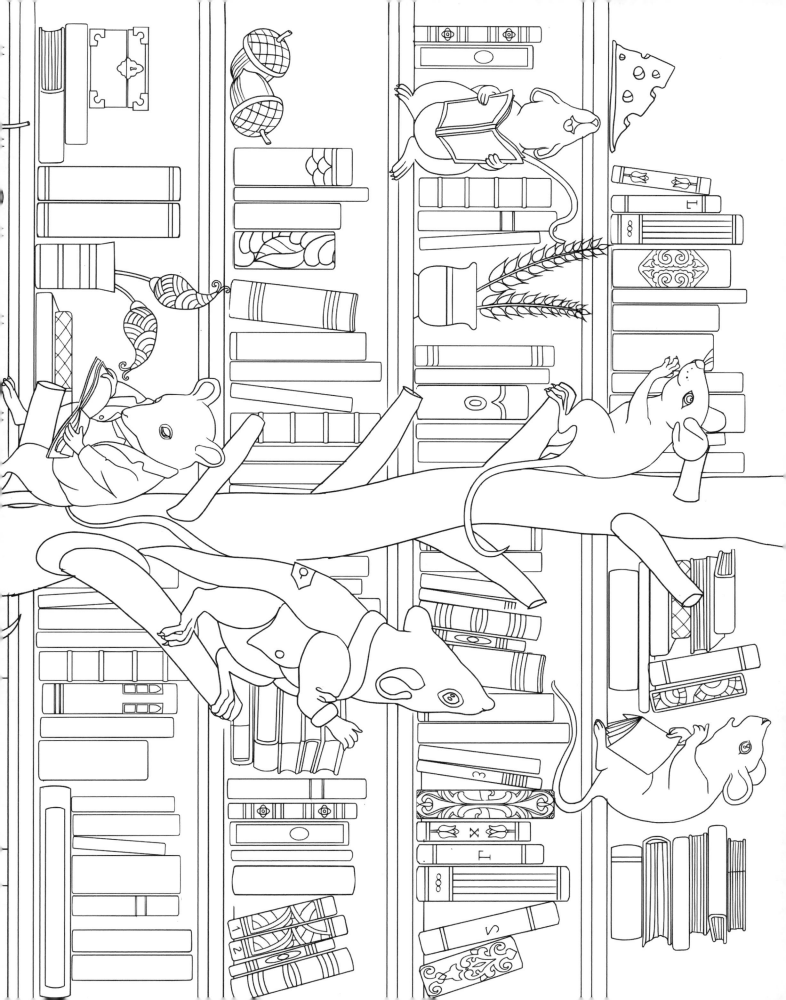

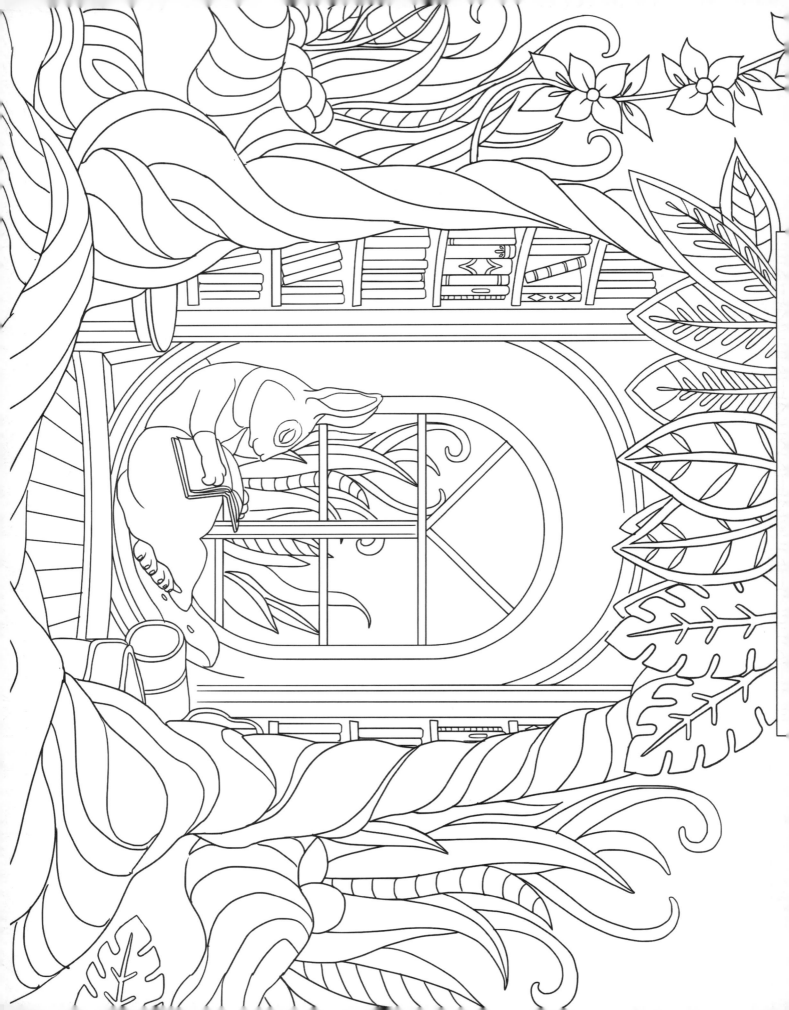

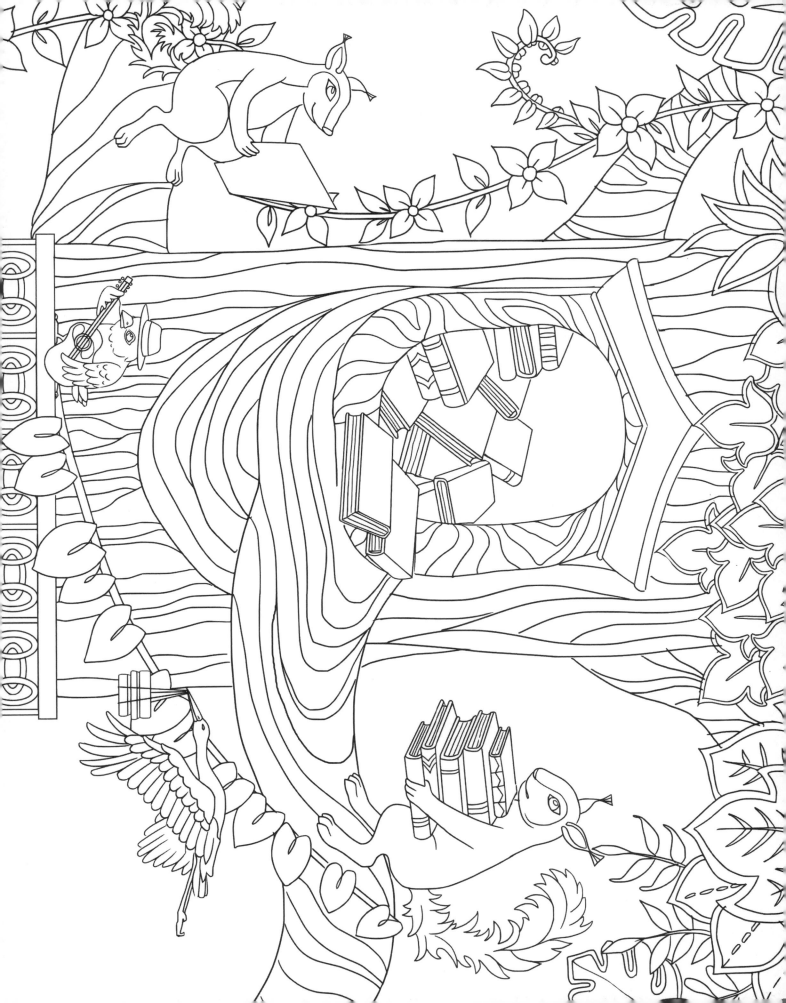

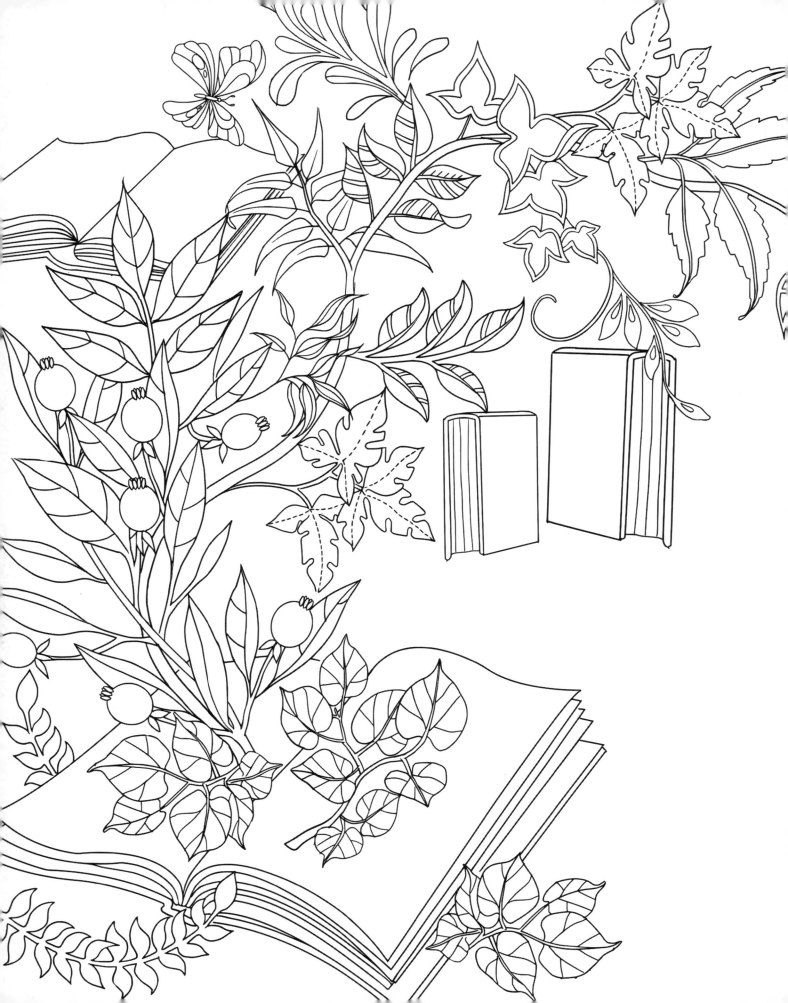

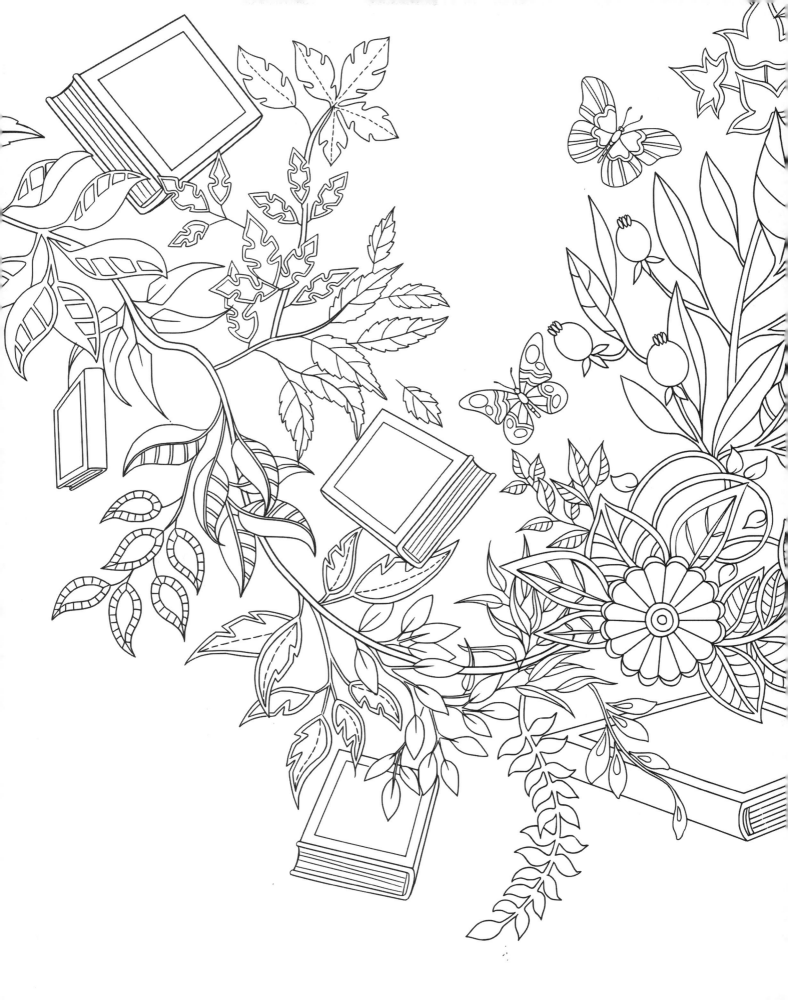

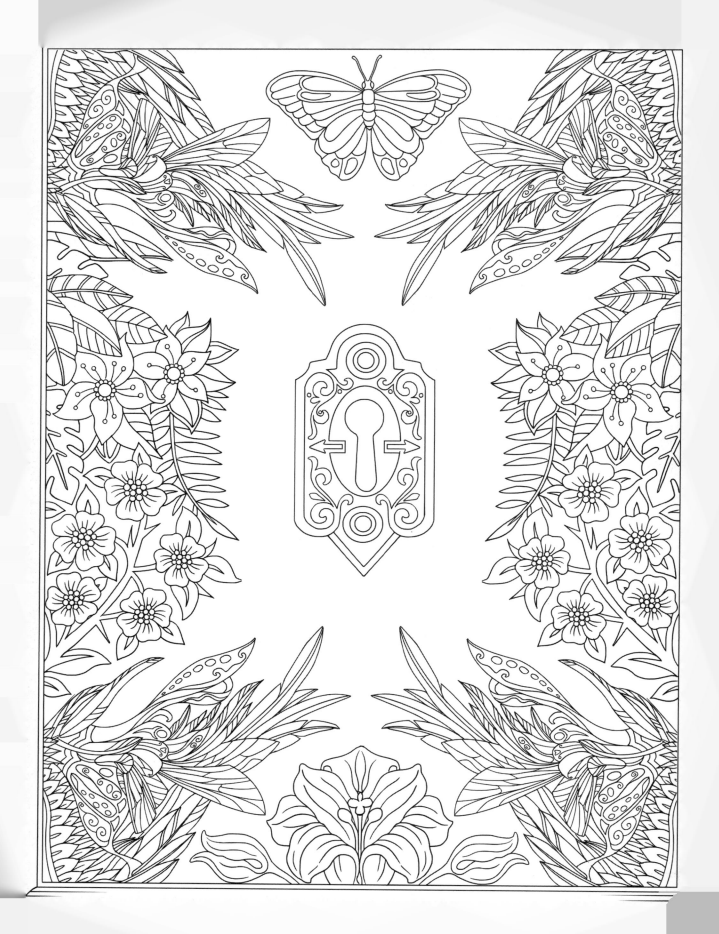

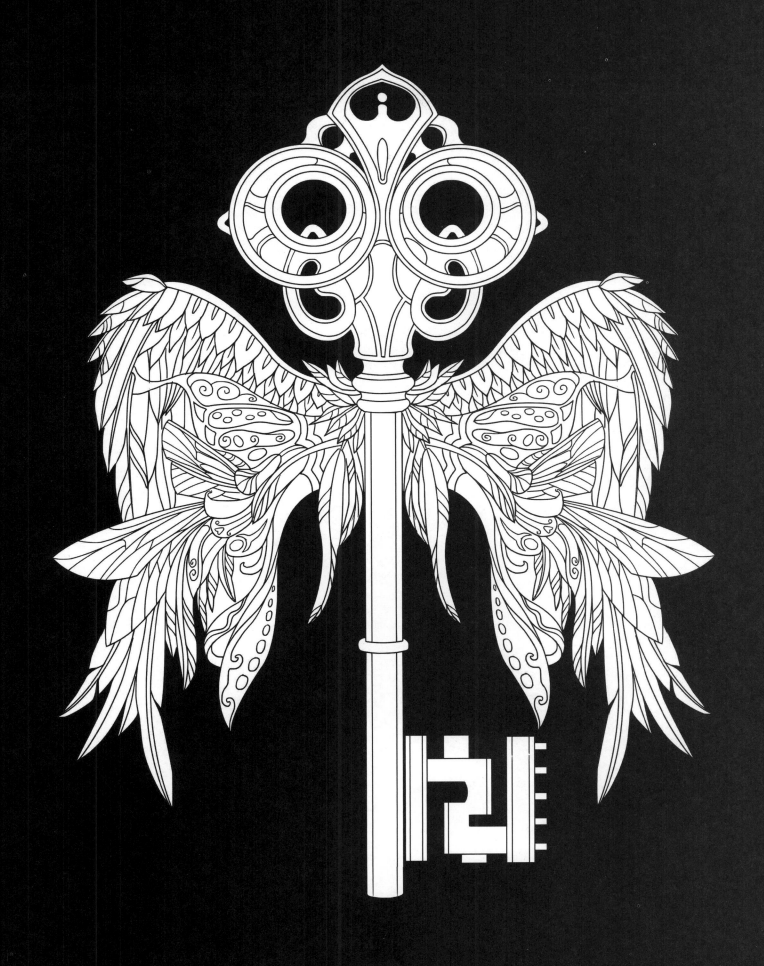

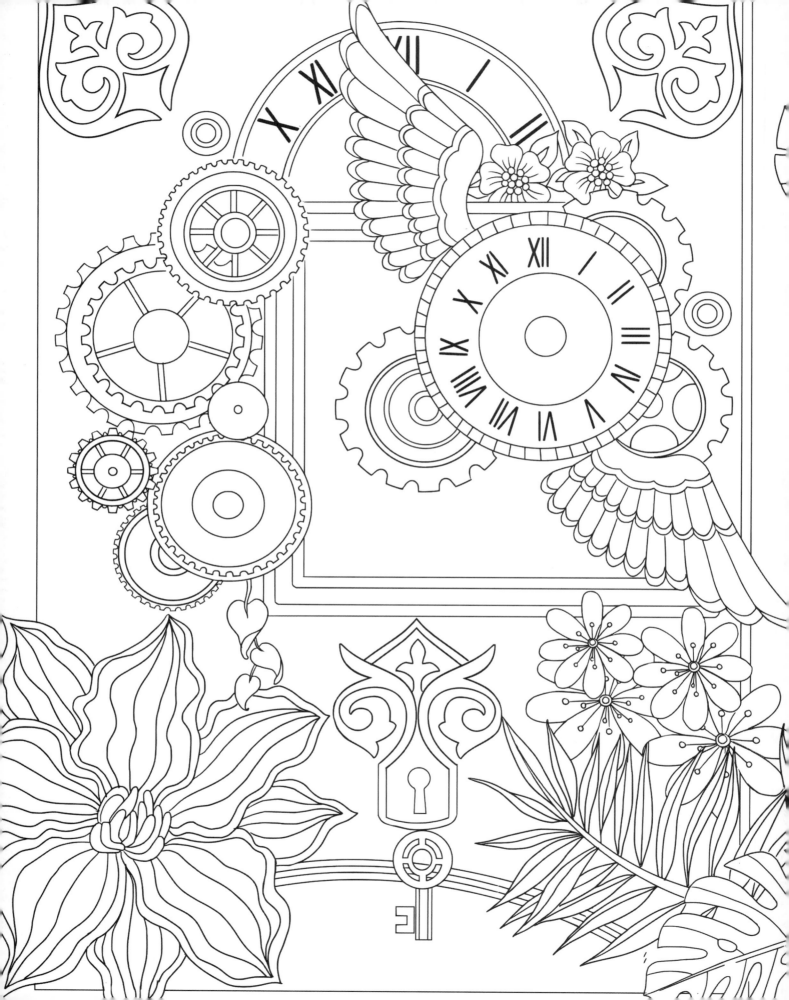

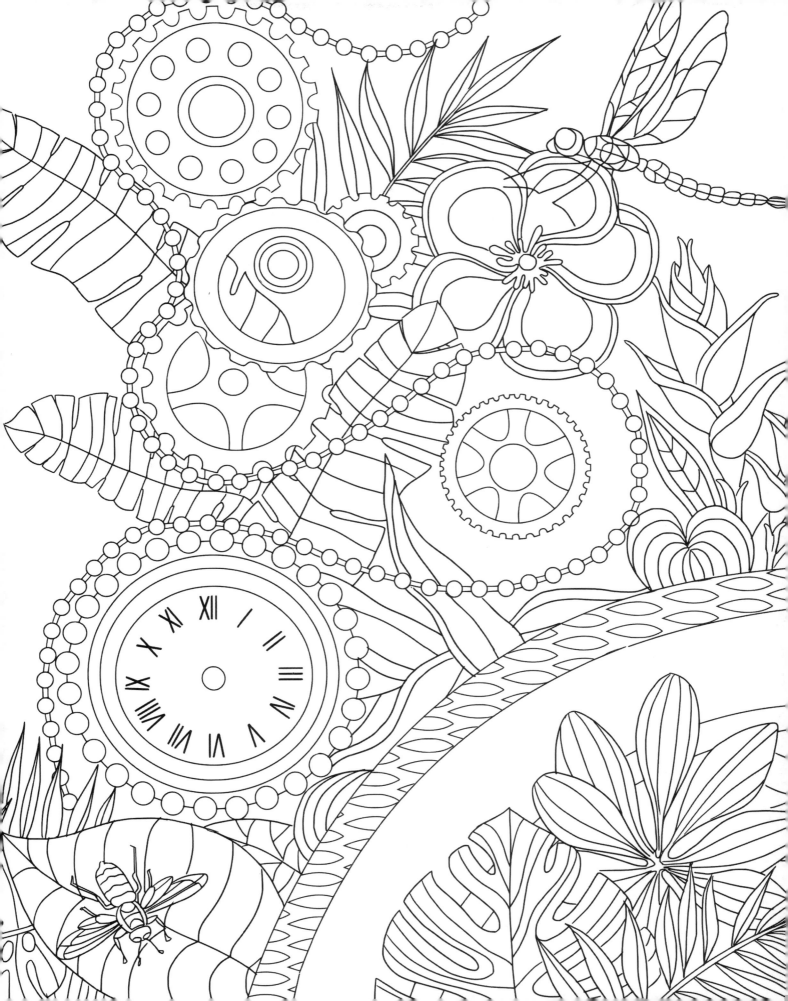

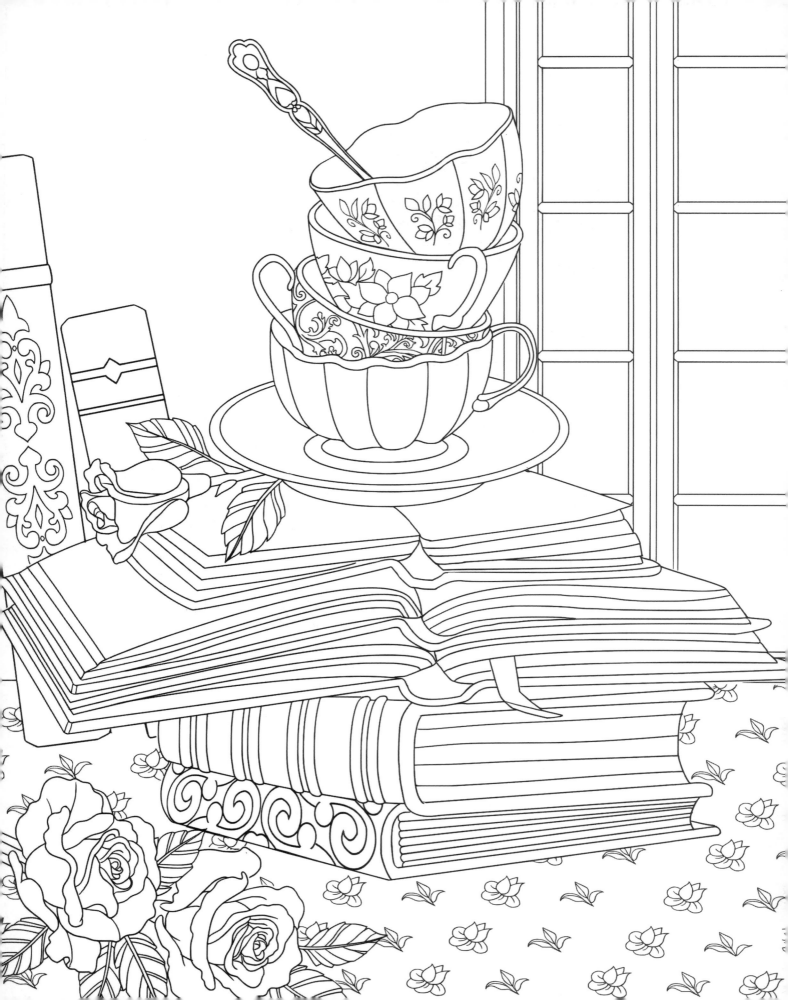

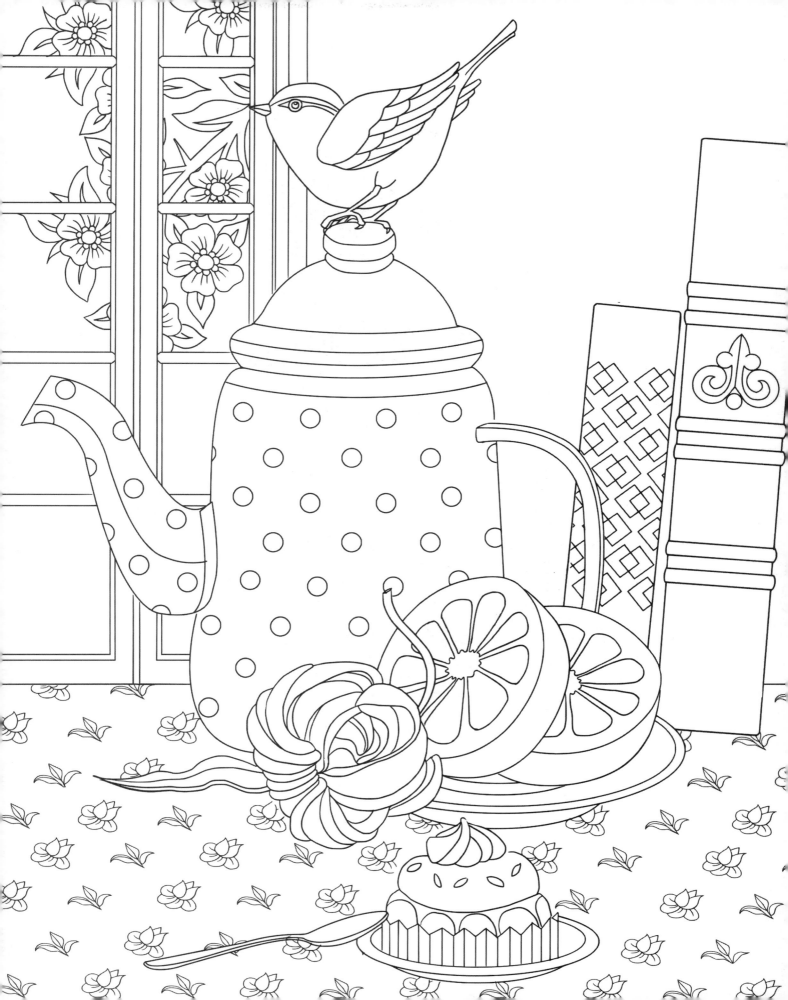

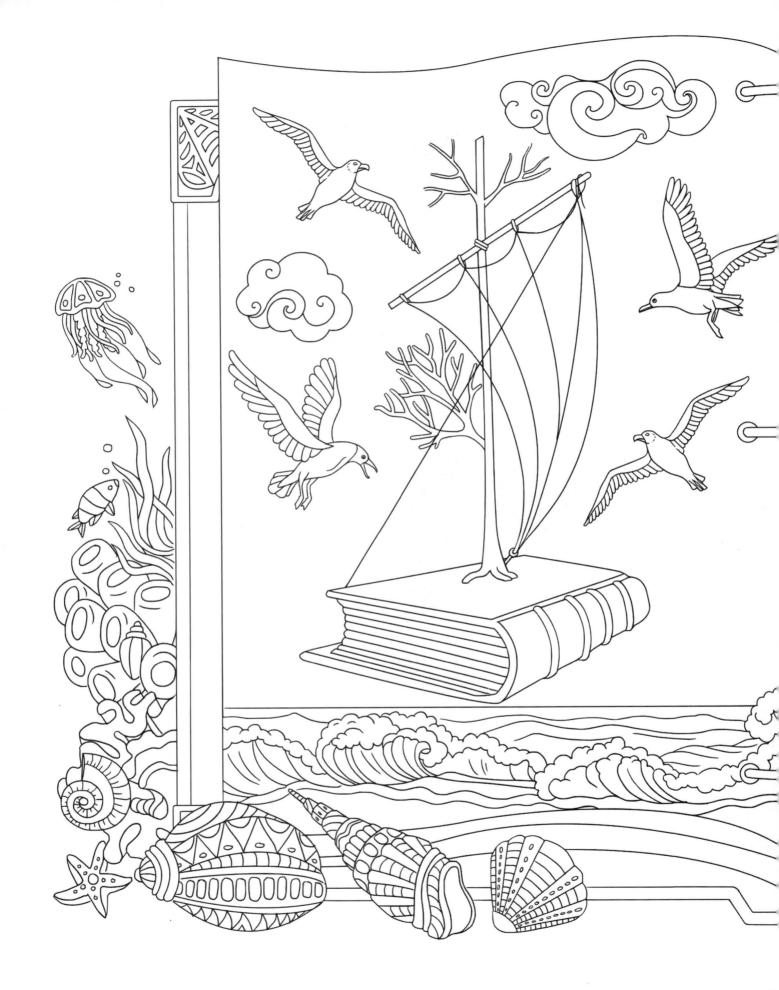

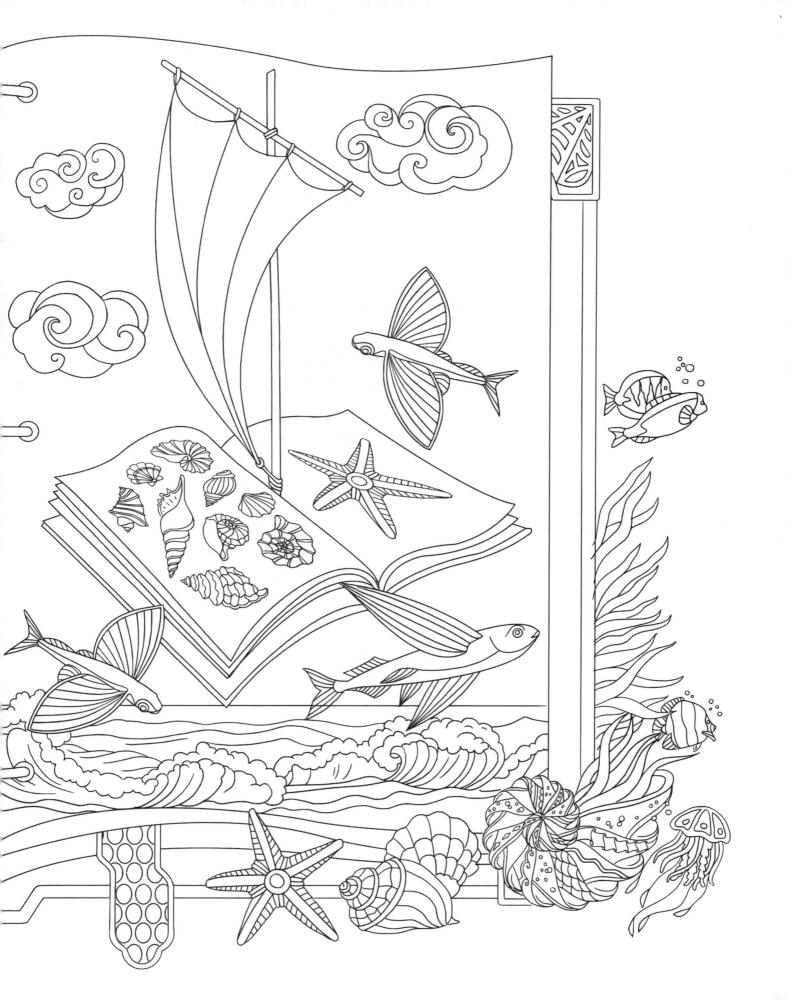